WITHDRAWN

THE GREAT AMERICAN
POP ART STORE

MULTIPLES OF THE SIXTIES

THE GREAT AMERICAN POP ART STORE

MULTIPLES OF THE SIXTIES

CONSTANCE W. GLENN

WITH CONTRIBUTIONS BY LINDA ALBRIGHT-TOMB,
DOROTHY LICHTENSTEIN, AND KAREN L. KLEINFELDER

Published on the occasion of an exhibition
curated by Constance W. Glenn and organized by the

University Art Museum
College of the Arts, California State University, Long Beach

Smart Art Press, Santa Monica, California
in association with the University Art Museum
California State University, Long Beach

EXHIBITION SCHEDULE

University Art Museum
California State University, Long Beach
August 26 – October 26, 1997

The Jane Voorhees Zimmerli Art Museum
Rutgers University, New Brunswick, New Jersey
November 22, 1997 – February 22, 1998

The Baltimore Museum of Art
Baltimore, Maryland
March 25 – May 31, 1998

Montgomery Museum of Fine Arts
Montgomery, Alabama
June 27 – August 23, 1998

Frederick R. Weisman Art Museum
University of Minnesota, Minneapolis
October 3 – December 6, 1998

Marion Koogler McNay Art Museum
San Antonio, Texas
January 18 – March 14, 1999

Wichita Art Museum
Wichita, Kansas
April 11 – June 6, 1999

Muskegon Museum of Art
Muskegon, Michigan
July 29 – September 12,1999

Joslyn Art Museum
Omaha, Nebraska
October 23, 1999 – January 9, 2000

Lowe Art Museum
University of Miami, Coral Gables, Florida
February 3 – March 26, 2000

The Toledo Museum of Art
Toledo, Ohio
June 4 – August 13, 2000

UNIVERSITY ART MUSEUM

Constance W. Glenn, Director
Ilee Kaplan, Associate Director
Kirsten Schmidt, Director of Public Relations
 and Publications
Marina Freeman, Registrar and Curator
 of Collections
Meg Linton, Curator of Exhibitions
Elizabeth Harvey, Education Coordinator
William Vaughan, Preparator
Darius Ilgunas, Accountant

©Text, University Art Museum, California State
University, Long Beach
©Images, the artists, publishers, and photographers
©1997 Smart Art Press
Smart Art Press
2525 Michigan Avenue, Bldg. C1
Santa Monica, California 90404
Tel 310. 264.4678 Fax 310. 264.4682
Email T16ySAP@aol.com
All Rights Reserved
ISBN: 0-936270-36-5

THE GREAT AMERICAN POP ART STORE
MULTIPLES OF THE SIXTIES
is a traveling exhibition supported, in part,
by the National Endowment for the Arts,
with additional funding by the Instructionally
Related Activities Fund and the College of the Arts,
California State University, Long Beach,
the California Arts Council, and the
Will J. Reid Foundation.

This book was designed by Marika van Adelsberg,
typeset in Futura, and printed by Jomagar S/L,
Madrid, in an edition of 3,000 copies.

Cover: Claes Oldenburg, Tom Wesselmann, Roy
Lichtenstein, fashion model Jean Shrimpton, James
Rosenquist, and Andy Warhol at a party at the
Factory, 1964 © Ken Heyman

ACKNOWLEDGEMENTS

During the four years since this exhibition was initiated, many people have been most generous in assuring its realization. To recreate the history of the decade, we relied heavily on Rosa Esman, Marian Goodman, Dorothy Lichtenstein, Ben Birillo, Barbara Kulicke, Robert Kulicke, Joan Kron, Audrey Sabol, Billy Klüver and Julie Martin, Bob Stanley, Mary Lee Corlett, Joan Washburn, Alice Denny, John Powers, Babs Thomson, Elyse Grinstein, and Ivan Karp, all of whom contributed significantly.

In assembling the works of art and providing essential documentation David Platzker, Cassandra Lozano, Andrew Richards, Sidney B. Felsen, Richard Solomon, Blake Summers, Ann Marie McIntyre, Tara Reddi, Matt Bult, Nina Felshin, Pat Poncy, Sara Seagull, Beverly Coe, Michael Harrigan, Tim Hunt, Thomas Sokolowski, Mark Francis, Cheryl Saunders, Matt Wrbican, John Smith, Bert Stern, Paul Cornwall-Jones, Steven Leiber, David White, and Barbara Bishop and the staff of the West Coast Regional Center of the Archives of American Art, Smithsonian Institution, were especially helpful, and we are all grateful for the time they devoted and for their many kindnesses.

Locating important 1960s photographs was especially difficult and we thank Woody Woodfin of Woodfin Camp & Associates, Inc., Stephen Shore, Ken Heyman, Henri Dauman, Nina del Rio, Judith Golden, and Bert Stern for their invaluable contributions to this book. Mark Chamberlain ably created new and copy photographs.

As always, the staff of the University Art Museum has played the most important role. This project would not have succeeded without Kirsten Schmidt's great skill in assembling this book or Marina Freeman's devotion to finalizing the loans. Ilee Kaplan deserves great credit, as do former staff members Linda Albright-Tomb, who devoted her thesis to this project, and Gwen Hill, who developed the tour. We are, in turn, indebted to Dr. Karen Kleinfelder, the CSULB College of the Arts and the Instructionally Related Activities Fund, and,

most importantly, we gratefully acknowledge the crucial support of the National Endowment for the Arts.

This publication would not have been realized without the very generous support of Tom Patchett and Smart Art Press, where Susan Martin provided wise counsel and assistance. Together we extend a special thank you to designer Marika van Adelsberg and copy editor Sue Henger.

Finally, to the artists and lenders who gave unstintingly of their time, offered works so willingly, and in every way made this project a delight, I extend my heartfelt gratitude on behalf of the University Art Museum and every individual associated with *The Great American Pop Art Store*.

CONSTANCE W. GLENN
DIRECTOR

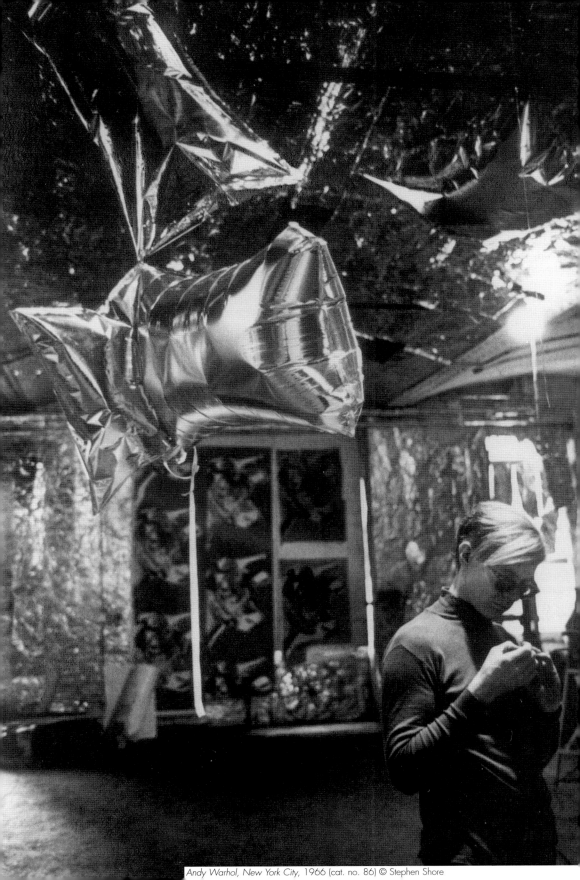

Andy Warhol, New York City, 1966 (cat. no. 86) © Stephen Shore

INTRODUCTION

LINDA ALBRIGHT-TOMB

In the early 1960s, when the Liverpool lads took England by storm and the Beach Boys were "Surfin' USA," when the Freedom Riders were protesting Southern segregation and the Pill was sending shock waves through Ozzie and Harriet families, a curious kind of art called the "multiple" began to crop up in conversations among the devotees of the new art scene. From Paris to New York, from London to Milan, artists and enthusiasts began to pay note to this novelty which, in time, worked its way not only into the hearts and homes of a knowledgeable few, but also into upscale galleries and the collections of major museums.

The multiple had—and still has—almost as many definitions as incarnations. Generally, it was understood to be a three-dimensional object that was intended to exist not as a unique work of art, but as an editioned original. The multiple gained its identity, in part, through the process of mass fabrication.[1] Often this involved a unique prototype, but that prototype was used merely as a template to produce the object in either a predetermined or unlimited edition.[2] Frequently, the artist conceived the work while someone else—an assistant, a fabricator—brought the idea to fruition. This practice was altogether opposed to those methods which were employed to produce works of art that were necessarily singular, select, and—as was so often the case—expensive. As one early publisher observed at the time, "We'd like to take the snobbism out of art collecting. . . . We hope to make art available to those who can't afford major works."[3] However, a number of other factors motivated artists who produced multiples.

For some, [a multiple was] a simple extension of their one-off artworks; for others, a way of exploring industrial techniques as a new discipline; for yet others, a way of getting their art into homes rather than galleries. Some express[ed] defiance on a cultural or political level; others, simply a pragmatic desire to sell their wares.[4]

In Europe and America, artists of every persuasion enthusiastically embraced this latest art form. Conceptual, Fluxus, Minimal, and Pop Art aesthetics were reflected in an array of objects. Pop Art multiples, however, differed dramatically from others. They were, in fact, evidence of the much larger movement in which everyday images and icons—from Marilyn Monroe to Mickey Mouse—provided the subject matter for art. Collectively, American Pop Art multiples represented a pictorial slice of the 1960s.

In contrast, European multiples, as well as those produced by other American artists (such as Minimalist Sol LeWitt or Fluxus founder George Maciunas), were either essentially sculptural or more akin to the tradition initiated by Marcel Duchamp (and extended by Beuys), and thus were primarily conceptual in nature. The ideas behind these works far outweighed the objects themselves. German artist Joseph Beuys' multiple *Intuition . . . Instead of a Cook-Book* (1968)—a plain wooden box with a scrawled pencil drawing—appears markedly different from Andy Warhol's *Silver Clouds* (1966)— helium-filled balloons that gallery-goers were encouraged to bat about the room. Clearly, two distinct aesthetics were at work: one conceptual, hermetic, and obscure, the other open, playful, and participatory.

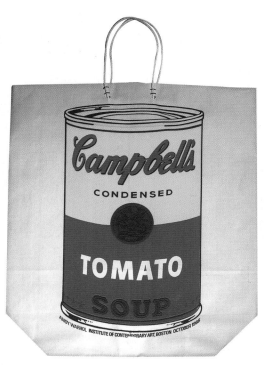

Andy Warhol, *Campbell's Soup Can Shopping Bag*, 1966 (cat. no. 84) © 1997 The Andy Warhol Foundation for the Visual Arts/Artists Rights Society (ARS), NY

Over the last several decades, a number of individuals have tried to bring order to the complex history of multiples. The European tradition, in particular, has been the primary focus of exhibitions and catalogues produced in Cologne, Berlin, London, and Hamburg. The life of the American Pop Art multiple, however, has never been discretely documented.[5] Many of the objects have either disappeared or disintegrated; original records are now scarce and scattered. By bringing together more than one hundred of these multiples and presenting them in their historical context, *The Great American Pop Art Store: Multiples of the Sixties*[6] seeks to recapture the adventurous spirit of the era and, in so doing, tell the story of the multiples Pop spawned.

FROM DUCHAMP TO. . .

Although the concept of multiple originals has existed for centuries,[7] Marcel Duchamp is considered the founder of the modern genre. As early as 1913, he flipped an ordinary bicycle wheel on its head, stuck it through a stool, and labeled it "art." Consequently, *a* bicycle wheel became *the Bicycle Wheel*. With this introduction of the Readymade, Duchamp originated the subversive notion of recontextualizing a common object. The intent and idea took precedence over the physical form. Moreover, by creating *Bicycle Wheel* three times, he stressed that works of art need not be singular and that each version possessed equal value. "To Duchamp, one was unique, two was a pair, and three was 'many.' To make three was to mass-produce."[8]

Duchamp championed iconoclastic ideas throughout his lifetime and profoundly affected generations of artists both here and abroad. During the period which gave birth to Pop Art, he reissued a number of his earlier multiples. For example, *Rotorelief* (1935) was re-editioned four times between 1953 and 1965,[9] while *Boîte en Valise* (1941), was reissued on three occasions between 1958 and 1968.[10] In addition, in 1964, in honor of the fiftieth anniversary of his first Readymade, Duchamp produced *The Bottle Dryer* (edition 8), a collection for which he re-editioned selected Readymades that had been lost or destroyed (including *Bicycle Wheel*).[11] To the artist, the publication of this last portfolio was the most effective way to "save these Readymades from oblivion."[12]

Duchamp was not alone in his "attack on the fetishism surrounding the uniqueness of works of art."[13] Man Ray and László Moholy-Nagy also fueled the fight. In 1920 Man Ray, for example, submitted a paper lampshade (stripped of its metal framework) to an exhibition presented by the Société Anonyme, Inc., in New York. "Believing this to be part of the wrapping paper, a diligent cleaner proceeded to tear it up."[14] Unfazed, the artist provided a painted white metal replacement. Thereafter, he reissued the work whenever necessary (which he did on approximately twenty different occasions), each time emphasizing the reproducible nature of art.[15]

A prominent figure in the German Bauhaus school of art, craft, and design, Moholy-Nagy openly embraced the union of art and technology. Industrial processes were hailed as the way for artists and designers to mass-produce their work, thereby making it more widely available to a broad public.[16] Moholy, like Man Ray, effectively "wage[d] war on the cult of the original."[17] For his *Telephone Pictures* (1922), he ordered five porcelain enamel paintings over the phone from a sign factory. Describing to the contractor the exact compositions, colors, and dimensions, he effectively eliminated the need for his involvement in the fabrication of the works.

Swiss artist and entrepreneur Daniel Spoerri upped the ante in 1956 when he approached Parisian art dealer Denise René with the idea of formally publishing editioned works by a wide variety of contemporary European artists. René declined the invitation on the grounds that collectors were not yet ready for such a concept, advising Spoerri instead to first produce unique works from which subsequent editions could be made.[18] Undaunted, in 1959 Spoerri published *Collection '59* (edition 100) under the auspices of his newly formed Édition MAT (which stood for *Multiplication d'Art Transformable*). Each portfolio consisted of fourteen objects—variable in form and thus retaining a degree of traditional uniqueness—a number of which were by noted avant-garde artists, ranging from Duchamp to Victor Vasarely.[19] Ultimately, René was right. Barely any portfolios sold that year.[20] However, Spoerri had initiated what would soon become a viable aspect of the graphics renaissance of the period.

In late-fifties America, the reigning art movement, Abstract Expressionism, was gradually giving way to a bold, fresh style ushered in by a younger generation of artists who turned to the environment around them for inspiration. In 1958 Allan Kaprow eloquently explained:

Pollock, as I see him, left us at the point where we must become preoccupied with, and even dazzled by the space and objects of our every-day life, either our bodies, clothes, rooms, or, if need be, the vastness of Forty-Second Street. . . Objects of every sort are materials for the new art: paint, chairs, food, electric and neon lights, smoke, water, old socks, a dog, movies, a thousand other things which will be discovered by the present generation of artists. Not only will these bold creators show us, as if for the first time, the world we have always had about us, but ignored, but they will disclose entirely unheard-of happenings and events, found in garbage cans, police files, hotel lobbies, seen in store windows and on the streets, and sensed in dreams and horrible accidents. An odor of crushed strawberries, a letter from a friend or a billboard selling [Drāno]; three taps on the front door, a scratch, a sigh or a voice lecturing endlessly, a blinding staccato flash, a bowler hat—all will become materials for this new concrete art.[21]

Embedded in this exuberant mix of the vernacular were the Happenings which Kaprow was among the first to organize. Many artists—Jim Dine and Claes Oldenburg, in particular—followed suit not only with performances but also with strange, new street-inspired environments as well.

Immersed in the culture of the streets, artists also began to absorb and process the new media barrage: billboards, cartoons, newspaper, and magazine advertisements dominated the visual landscape of postwar America. Eager to converse with this image-laden environment, they borrowed liberally from a pastiche of comic book characters and magazine mannequins. A popular girls' maga-zine published an article on Pop Art in which one teenager explained: "Today's art is different because our world is different from any previous one. . . . Instead of winding country roads," she continued, "we are likely to do most of our traveling on high-ways liberally edged with billboards, and the dinner Mother serves us may be frozen TV instead of home-cooked."[22] Her generation was, in fact, won over by a number of the pioneering artists. Alternatively labeled Neo-Dadaists, New Realists, and finally Pop artists, they soon found themselves the focus of mer-ciless media attention.

Claes Oldenburg's poster for *The Store*, 1961

Around the same time, a burgeoning renaissance in the art of printmaking was tempting the participation of artists on both coasts. Newly founded workshops such as Universal Limited Art Editions (West Islip, New York, 1957) and the Tamarind Workshop (Los Angeles, 1960) played pivotal roles in introducing new resources and technologies and training a remarkable generation of master-printers. With the revival of printmaking, editioned originals became viable and valuable alternatives to the singular work of art. Early collaborative print projects, such as artist Larry Rivers' and poet Frank O'Hara's landmark portfolio *Stones* (1957–60; ULAE), were instrumental in elevating the status of contemporary publications.

Concurrently, industrial technologies formerly monopolized by the war effort, such as vacuum-forming, welding, and chrome-plating, had become more widely available. Cottage industries soon emerged in unlikely places in order to serve a growing number of artists and publishers eager to experiment. They were now able to utilize the manufacturing processes not only to realize their ideas but also to mass-produce them. "The machine, long the enemy of art," claimed critic John Gruen, "produces its very own aesthetic, and forward-looking artists have embraced the machine with open arms."

Indeed, today's artists consider the machine an extension of their own ability. They relish the notion of planning and programming their artworks on drawing boards and allowing trained operators and technicians to manufacture the final products. More often than not, the artist supervises the operation and is present during every step of the machine-made creation. What is more, the whole idea of machines producing . . . objects intrigues the artist. The vast possibilities inherent in commercial, mechanical and industrial processes ignite his imagination and, far from wishing to absent himself from such creativity, he goes to it with all manner of new inventiveness.
He knows, for example, that only a machine can effectively vacuum-form plastics; that only a machine can shape and mold neon tubing; that it can cut accurately, and to specification, any number of materials from steel to wood to glass to plastic. The artist also knows that a machine can do this again and again. Thus, each work of art produced in this manner has the look of technical perfection—a perfection that does not diminish by being duplicated.[23]

By 1964 American Pop artists were in an unprecedented position. Publishers devoted to allowing them to freely explore the possibilities of editioned originals had begun to emerge. The technology required to produce their work *en masse*, in both two and three dimensions, was now at their disposal. Finally, a new delight in common objects readily lent itself to the forthcoming multiples mania.

Familiar forms began to appear as editioned art objects. Robert Watts, for example, embalmed colored wax slices of bacon, lettuce, and tomato in a lucite sandwich (*Bacon, Lettuce and Tomato Sandwich*, 1966); Roy Lichtenstein baked an enamel hot dog onto steel (*Hot Dog*, 1964); and Tom Wesselmann molded a nude female torso by vacuum-forming Plexiglas (*Little Nude*, 1966). Eager to get involved, department stores began to sell multiple originals by prominent artists in newly formed art divisions, openly encouraging, as one reviewer noted, "the impulse shopper to buy art with his charge card."[24]

The bulk of Pop Art multiples production occurred between 1965 and 1969. Led by an enthusiastic few, it began in New York with the founding of the Betsy Ross Flag and Banner Company and its editioning of artist-designed banners. Shortly thereafter, Marian Goodman (of Multiples Inc.) and Rosa Esman (of Tanglewood Press Inc. and Original Editions) began to approach artists with the notion of translating their work into three-dimensional editions. Together, the artists and publishers searched for feasible methods to manufacture their designs. Often fanciful, sometimes naive, Pop multiples bloomed in tandem with the movement until the end of the decade. By that time, the now-famous artists had become increasingly drawn to more complex, more ambitious projects. Moreover, the lighthearted air that had previously prevailed gave way to more pragmatic concerns. The multiples themselves however remain, having evolved out of a decade of enthusiastic experimentation, to impact in surprising ways on art today.

Robert Watts, *Bacon, Lettuce, and Tomato Sandwich*, 1966 (cat. no. 98)

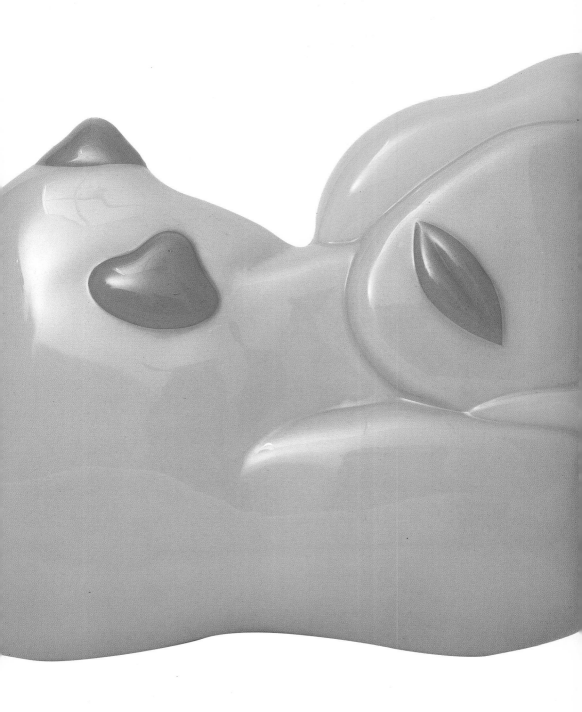

Tom Wesselmann, *Little Nude*, 1966 (cat. no. 102) © 1997 Tom Wesselmann/Licensed by VAGA, New York, NY

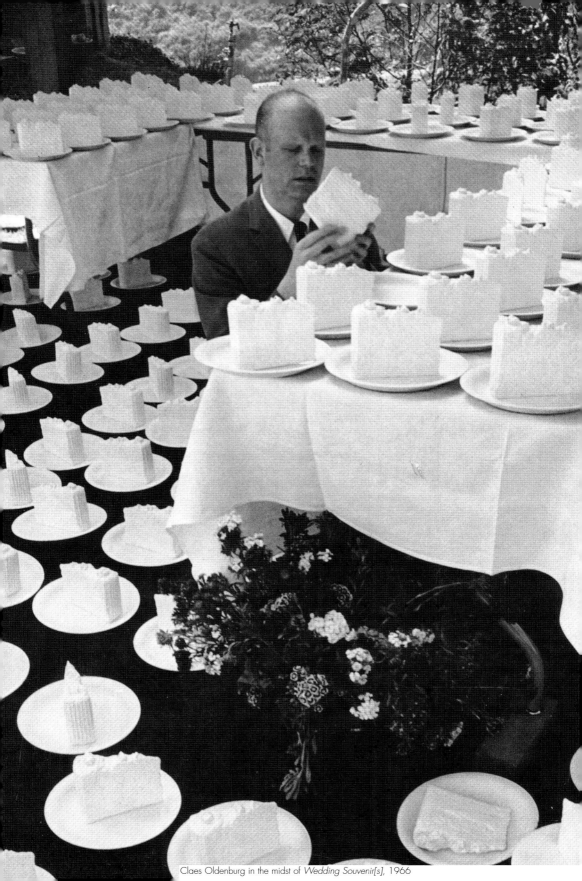

Claes Oldenburg in the midst of *Wedding Souvenir[s]*, 1966

NOTES

1. In this context, the words "mass fabrication" and "mass production" are used interchangeably. They do not necessarily imply large numbers, but rather refer to the use of industrial processes.

2. An unlimited edition is, in fact, a contradiction in terms, since all objects ultimately exist in measurable quantities.

3. Barbara Kulicke, quoted in "Art Notes: M-M-Multiples," *The New York Times,* 31 October 1965, p. 29.

4. Andrew Patrizio, "Multiples Today: A Consumer's Guide," *Art Unlimited: Multiples of the 1960s and 1990s from the Arts Council Collection* (London: The South Bank Centre, 1994), 57.

5. Previous surveys of art multiples include (1) *Ars Multiplicata,* 1968, Cologne, which dealt primarily with prints of the 1950s and 1960s; three-dimensional objects were confined to those produced by Édition MAT and a few done by American Pop artists; (2) *Three ->∞ : New Multiple Art,* 1970, London, which placed more emphasis on three-dimensional objects but did not single out those by Americans; (3) *Multiples, The First Decade,* 1971, Philadelphia, which was the first attempt to explain and exhibit multiples in the U.S.; it excluded prints and represented a cross-section of international multiples production of the 1960s; (4) *Multiples, An Attempt to Present the Development of the Object Edition,* 1974, Berlin, which sought to present a comprehensive history of the development of the multiple, with a heavy focus on Duchamp and Beuys; (5) *Three or More—Multiplied Art from Duchamp to the Present,* 1992, Tokyo, which attempted to comprehensively index multiples, but is incomplete, particularly with regard to the American Pop artists; (6) *The Pop Image: Prints and Multiples,* 1994, New York, which considered prints and multiples in the same context; (7) *Das Jahrhundert des Multiple Von Duchamp bis zur Gegenwart,* 1994, Hamburg, which, while innovative in style and presentation, barely touched upon American Pop Art multiples; (8) *Art Unlimited: Multiples of the 1960s and 1990s from the Arts Council Collection,* 1994, London, which provided an excellent historical overview of multiples but retained a primarily European focus.

6. *The Great American Pop Art Store: Multiples of the Sixties* was named in remembrance of the 1964 landmark exhibition, the *American Supermarket* (at the Bianchini Gallery in New York).

7. Egyptian seals, African masks, and Renaissance woodcuts are but a few examples of objects which, from the outset, were intended to exist in number.

8. Marian Goodman and John Loring, "To Create is Divine, To Multiply is Human," in René Block, *Multiples: An Attempt to Present the Development of the Object Edition* (Berlin: Neuer Berliner Kunstverein, 1974), 26.

9. *Rotorelief* contained six discs with drawings meant to be viewed at 33 rpm. It was reissued in New York in 1953 (edition 1000) and 1963 (edition 16); in Paris in 1959 (edition 100); and in Milan in 1965 (which was a reissue of the remaining 150 from the 1953 edition).

10. *Boîte en Valise* included miniatures of some of Duchamp's most significant works. It was re-editioned in Paris in 1958 (edition approximately 30) and 1959 (edition approximately 60); and in Paris-Milan in 1955-68 (edition 100).

11. The portfolio *The Bottle Dryer* (1964) was separate from the earlier Readymade *Bottle Dryer* (1914), which was also recreated for this portfolio.

12. Arturo Schwarz, "Marcel Duchamp and the Multiple," in Block, *Multiples,* 47.

13. John Tancock, *Multiples: The First Decade* (Philadelphia: Philadelphia Museum of Art, 1971), unpaginated.

14. Ibid.

15. Ibid.

16. In 1935, German philosopher Walter Benjamin added to the debate over original works of art with his seminal essay "The Work of Art in the Age of Mechanical Reproduction." He insisted that art that used mechanical reproduction processes—such as film and photography—necessarily broadened the definition of originality to include art of a reproducible nature. "By making many reproductions," he contended, photography "substitutes a plurality. . .for a unique existence. . . . From a photographic negative, for example, one can make any number of prints; to ask for the 'authentic' print makes no sense." Quoted in Berel Lang and Forrest Williams, eds., *Marxism and Art: Writings in Aesthetics and Criticism* (New York: David McKay, 1972), 285, 287.

17. Hans Wallenberg, "Introduction," in Block, *Multiples,* 7.

18. Tancock.

19. All works in the portfolio were transformable. That is, they were either kinetic in nature or in some way changed form as they were assembled. As a result, each one could be considered unique. For example, a motorized multiple by Jean Tinguely invited the spectator to add random objects to its center; thus each version differed from the others in the edition.

20. Hilary Lane, "'To create is divine, to multiply is human' (Man Ray)," *Art Unlimited,* 20-21.

21. Quoted in Ellen H. Johnson, ed., *American Artists on Art From 1940 to 1980* (New York: Harper & Row, 1982), 58.

22. Sixteen-year-old Linda Kohn, "In my opinion: Teens should open their eyes to Pop, op, top, and hop," *Seventeen* 25 (April 1966): 272.

23. John Gruen, "Art's New 'Originals,'" *American Home* 73 (April 1970): 50, 52, 53.

24. "Retailing: Art over the Counter," *Time,* 7 May 1965, 94.

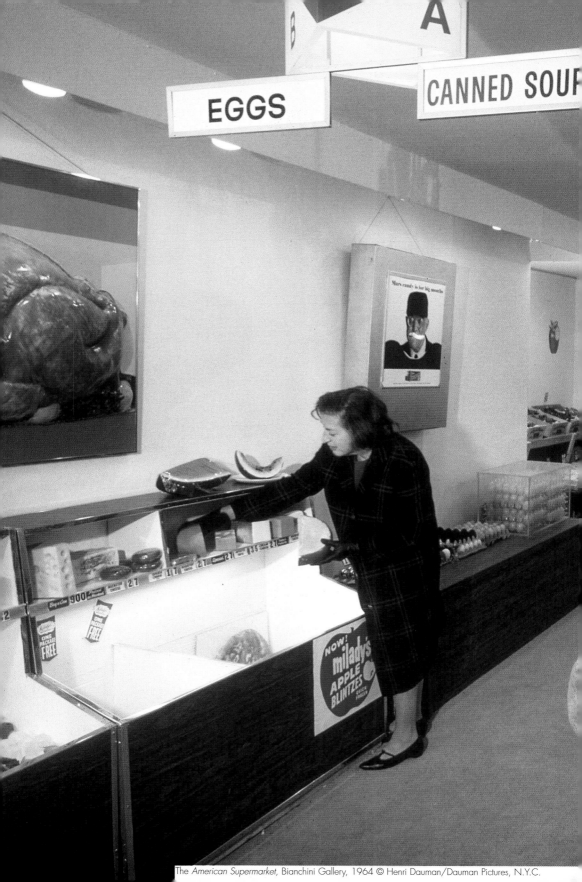

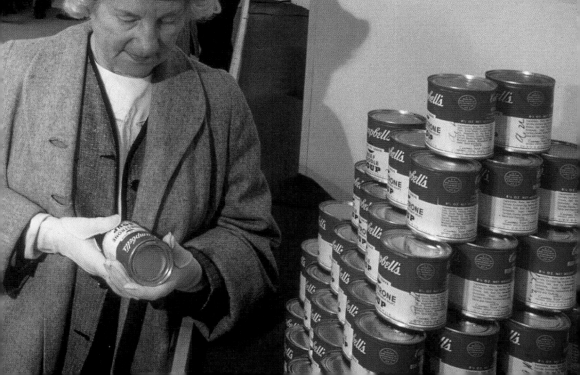

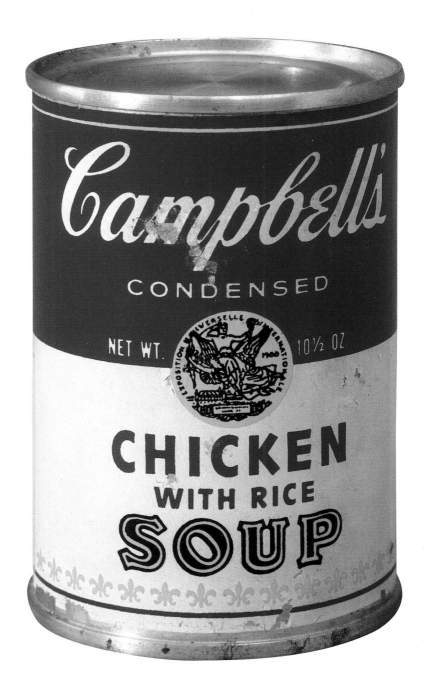

Andy Warhol, *Campbell's Soup Can*, ca. 1965 (cat. no. 82) © 1997 The Andy Warhol
Foundation for the Visual Arts/Artists Rights Society (ARS), NY

THE GREAT AMERICAN POP ART STORE MULTIPLES OF THE SIXTIES

CONSTANCE W. GLENN

The rituals encoded in these works, however lightheartedly, concern the erotics of consumption. They are about simple pleasures given form and purpose by social conventions. They are about life and the continuation of life. . . . And the multiples have, in their proliferation, a rampant sexiness, whether their subject be food, technology or the city.

—Thomas Lawson,
Claes Oldenburg:
Multiples in Retrospect 1964-1990

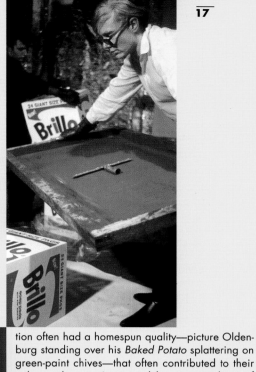

Who took them seriously, the Pop Art multiples of the sixties? In the beginning they were modestly priced, few in number (average edition 75), and relatively expendable accoutrements of the lifestyle of a young Pop crowd that was equally hip to Happenings, Courrèges boots, and Warhol film parties. The mood was upbeat and so were the objects. Their fabrica-

tion often had a homespun quality—picture Oldenburg standing over his *Baked Potato* splattering on green-paint chives—that often contributed to their ephemeral nature. It was said they were evidence of the artists' genuine desire to communicate with a much broader public or, conversely, they were art knick-knacks, editions precipitated by publishers bent on capitalizing upon the growing fame of the artists. Although both appraisals held kernels of the truth, what critics did not foresee was the degree to which the collaborations would foster experimentation in the use of new technology and non-art materials (especially plastics), and offer artists the opportunity to play a renaissance role in the world of mass-produced arts. Pop multiples set the stage for the time when, for better or for worse, artists would design everything from dinnerware and carpets to Swatch watches and table lamps; at their best, these objects challenged assumptions which equated quality with rarity, handmade gesture with potent content, and size with magnitude of idea. However voraciously collected by an initiated few, Pop editions were never thought of as precious. Often as not they were useful. Oldenburg's cake was *the* cake at a friend's wedding. Dinner arrived on Lichtenstein's dishes; his modern brooch, at $25, was purchased to wear. While certain objects were simply used, others were, in due course, used up. Many, in fact, did not survive. In the course of the last thirty years, those that did have become surprisingly rare—invested with a great importance which belies their unpretentious origins. Time has made them everything they were not, were never intended to be: precious, expensive status items.

Even though sculpture-oriented, typically kinetic or transformable multiples—perched perilously

on the edge of trinketness—were editioned in Europe as early as 1959, it would be five years before classic Pop editions would spring from a different impulse, from an affluent postwar American tradition steeped in optimistic consumerism. In retrospect, it was Andy Warhol's use of the silkscreen (beginning in 1962) to make vast numbers of identical originals, coupled with the supermarket/corner-store sensibility of Pop itself, that created a climate where a distinctly non-European brand of multiple would soon flourish. Warhol's signed cans of Campbell's soup (1962 –) and painted wood replicas of the cartons in which they were shipped; Claes Oldenburg's batches of painted plaster candies proffered at *The Store* (1961); Robert Watts' etched copies of dollar bills (1962) distributed as Fluxus/Pop currency—all spoke of a uniquely American moment.

The dawn of the sixties was a heady time for the Silent Generation. Art, for the first time, was not only on *our* shores but in the hands of *our* generation—thanks to the pioneering audacity of Robert Rauschenberg and Jasper Johns. Our revolution had really begun in 1958, when Rauschenberg and Johns stunned the art world (which Rauschenberg estimated consisted of some 500 artists, dealers, collectors, et al., while others limited it to 300) in their debut shows at Manhattan's year-old Castelli Gallery. From that moment, the avant-garde congealed rapidly, buoyed by snowballing activity on every front. Larry Rivers, Roy Lichtenstein, Andy Warhol, and George Segal—not yet Pop artists— had already shown their work in various New York galleries. By 1958 the younger generation—Jim Dine, Tom Wesselmann, Claes Oldenburg, and Jim Rosenquist—had all arrived in New York from the Midwest. The influence of John Cage, Merce Cunningham, and the experimental Black Mountain College circle was felt both through their own presence and through Rauschenberg's ongoing association with them, just as the Rutgers group—Roy Lichtenstein, George Segal, Lucas Samaras, Robert Whitman, George Brecht, and others—began to make themselves known, shepherded by the visionary teacher/artist Allan Kaprow, whose *18 Happenings in Six Parts* highlighted the 1959 Reuben Gallery season. By 1960 all of the pieces were in place for the debut of a gritty, street-smart new realism which would not officially be christened Pop Art until 1962.[1]

In 1960 the intermingling of art and everyday life—especially through Happenings and environments, which intentionally obscured the boundaries to the point where the two were often indistinguishable one from another—laid the foundation for the Pop lifestyle that artworld denizens would adopt in the years just ahead. That year Martha Jackson showed the puzzling art of the new avant-garde—much of which looked suspiciously like household junk—in a landmark exhibit, *New Forms—New Media II* (September 27 – October 22, 1960), while within a year Claes Oldenburg and Jim Dine created their environments, *The Street* and *The Home*, in a church space in Greenwich Village called the Judson Gallery. Richard Bellamy left the Hansa Gallery to found the influential Green Gallery (soon to be home to Oldenburg, Rosenquist, and Samaras) with funding from taxi mogul Robert Scull, while Hansa co-director Ivan Karp became the essential sales presence at the Castelli Gallery. The prevailing attitude among the new artists, and their contemporaries at large, was one of freewheeling optimism. They were, as a group, outgoing (as averse to the self-absorbed Abstract Expressionists) and inclusive rather than exclusive. Marcel Duchamp was still very much a presence on the New York scene, and the delicious irony of his Readymades, which were art because he named them so, was lost on no one. Politically it was a fresh, stimulating era in the world's most affluent country, governed at long last by a magnetic young president—the first to be born in the twentieth century—accompanied by a beautiful and cultured bride. With little hint of the turmoil that would mark the decade, art could—and soon did—make headlines.

I. 1960-1963: In the Beginning

It is essential to understand that there were two '60s . . . the good '60s ran from the civil rights sit-ins that began in February 1960 through the middle years of the decade, and centered on optimism, integration, sacrifice, devotion to community, and confidence in the capacity of government to play a role in making people's lives better.

Robert S. McElvaine,
Los Angeles Times, August 26, 1996

The creation of editions supposes a market, a market bolstered by big art names. In 1959 signed and numbered plates from books by such giants as Marc Chagall and Georges Braque sold briskly in Paris for around $50, while new-age multiples by a young circle of European artists, introduced in Cologne by Daniel Spoerri's Édition MAT, failed to find their niche. Yet by mid-decade prints and multiples by all of the American Pop Art core enjoyed an enthusiastic audience here and abroad. In that brief period, the center of the art world shifted decisively from the School of Paris to the School of New York; just as abruptly, the New York Abstract Expressionists were out of vogue and the Pop artists

were in *Life*. While Pop multiples in editions were not initially on anyone's mind, let alone in production, the years from 1960 to 1963 were crucial to both the solidification of the artists' fame—fame which would support the investment in editions—and the efflorescence of the new consumer society steeped in the confidence Pop Art so aptly reflected.

In 1960 Claes Oldenburg not only set about shaping his art from the objects, materials, signs, and refuse of life on Manhattan's Lower East Side, he also began to articulate the notions that would color the earliest multiples. In *The Store*—a project he presented in his 2nd Street studio from December 1, 1961 to January 31, 1962—he introduced the idea of art as an everyday product disbursed in a setting that referenced the places where we might purchase dry goods or vegetables. The lack of hierarchical distinctions he and his peers practiced—one object is no better than another, one subject is not superior to another—became key to the development of the new realism. Ultimately, too, the "store" concept itself would emerge as an important part of the manufacture, display, and sale of Pop Art multiples of the sixties.

The objects in Oldenburg's store—stockings, dresses, shirts, shoes, pies, chocolates, ice cream sandwiches—made of muslin, plaster, and chicken wire all dressed up in bold, sloppy, realistically colored paint were all possessed of a heightened reality, a reality that Oldenburg tried to express when he wrote:

> I am for the art of underwear and the art of taxicabs. I am for the art of ice-cream cones dropped on concrete. I am for the majestic art of dog-turds, rising like cathedrals.
>
> I am for blinking arts, lighting up the night. I am for art falling, splashing, wiggling, jumping, going on and off.
>
> I am for the art of fat truck-tires and black eyes.
>
> I am for Kool-art, 7-UP art, Pepsi-art, Sunshine art, 39 cents art, 15 cents art, Vatronol art, Dro-bomb art, Vam art, Menthol art, L & M art, Ex-lax art, Venida art, Heaven Hill art, Pameryl art, San-o-med art, Rx art, 9.99 art, Now art, New art, How art, Fire sale art, Last Chance art, Only art, Diamond art, Tomorrow art, Franks art, Ducks art, Meat-o-rama art.[2]

Not only had Oldenburg set into place the notion of the art store, he prophetically described the nature of the merchandise that, by 1965, would be editioned, signed, and numbered in abundance.

At the check-out counter in *The Store*, Oldenburg—the proprietor—kept a container of painted-plaster, ribbonlike candies which he sold or gave away to "clients" as the mood suited him, and although no two pieces were precisely identical, the spirit of Pop multiples was embodied in them. They were "products," they were modest, accessible in numbers, available to anyone who sought them out, witty, more than a bit tongue-in-cheek, part and parcel of the supermarket sensibility, and settled firmly in the world between art and life.

If all of this sounds a bit theatrical, theater was certainly part of the lineage of Pop Art and of Pop multiples. Following Allan Kaprow's lead, not only Oldenburg (with his weekly Ray Gun Theater held at *The Store*) but also Dine, Samaras, Segal and a number of the Fluxus artists were briefly but intensely involved in Happenings, and their installations were, in fact, theater pieces—Happenings frozen in time. College-trained, highly skilled draftsmen, and often accomplished commercial artists, the young Turks of Pop Art were entirely serious about reinventing the art world in the image of popular culture. They were ripe with the rich possibilities of a new decade and were possessed, even in the penniless years, of the same irrepressible spirit that drove the great bursts of new music, theater, dance, literature, fashion, film, and all other aspects of the "good" sixties.

Hard on the heels of the theatrics of *The Store* came the immediate predecessor of multiples in editions: identical—or serial—originals. Although Jasper Johns had made a series of multiple sculptures as early as 1958 and his renowned *Painted Bronze (Ale Cans)* (1960) had already achieved icon status, the number of casts he produced (two, as a rule) seemed to refer more to the tradition of nineteenth-century bronze casting than to the populist numbers (75 and above) that would characterize multiples. But, however influential Johns' objects may have been, it was Andy Warhol's serial originals that would set the stage. Look today at photographs of "Raggedy Andy"[3] standing amid row upon row of *Campbell's Soup* or *Brillo Boxes*, all apparently identical, all made possible by his discovery—in 1962—of the liberating convenience of the silkscreen. Even before creating the countless grocery cartons, in his first exhibition as a Pop artist—at Irving Blum's Ferus Gallery in Los Angeles in 1962—Warhol displayed 32 handpainted portraits of Campbell's Soup cans, each one indistinguishable from another except for the flavor. Not to mention the fact he signed (or initialed A.W.) and sold or gave away cans of the real thing, in numbers no one can guess today. Not only did Warhol's plentiful cans and silkscreened boxes suggest the possibility of editions, more importantly they significantly eroded the mystique of the unique

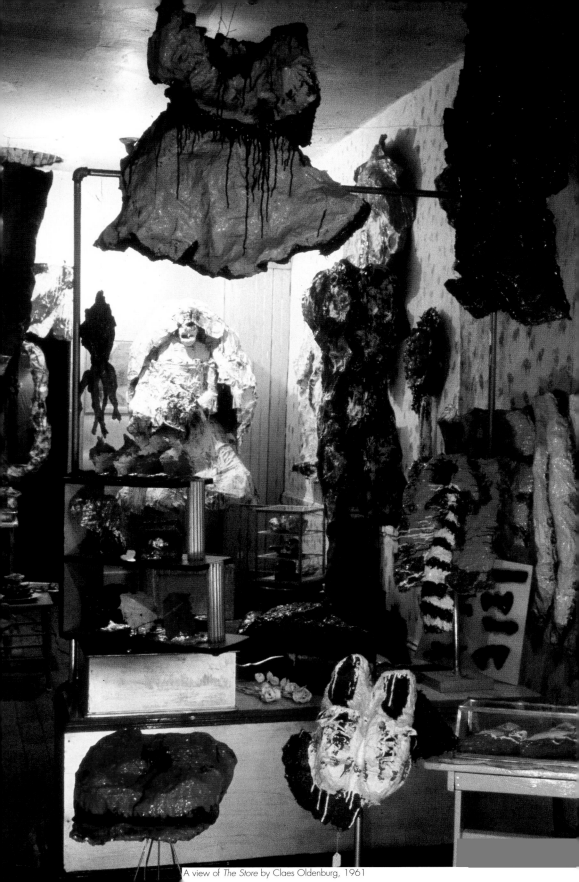

A view of *The Store* by Claes Oldenburg, 1961

Claes Oldenburg, *California Ray Guns*, 1963-64 (cat. no. 42), colors vary within sets
left, top to bottom; right, top to bottom

 Bell, Book, Fruit

 Bear, Woman, Fish

 Seahorse, Rabbit

 Cleopatra's Hair, Boy With Cap

 Angel, "God is Love"

 Horse, Wing

object, paving the way for the popular acceptance of multiple editions.

While printed editions—represented here by the transitional object/books by such artists as Ed Ruscha—participated in a tradition begun in the Renaissance and while objects as editioned multiples had precedent, however removed, in both bronze monuments and souvenir knick-knacks, it took a New York newspaper strike (114 days, from December 1962 to April 1963) to precipitate the first genuinely useful if totally unexpected editioned multiples of the Pop decade: the graphically captivating banners originally conceived by dealer Robert Graham to advertise exhibitions at the Graham Gallery on Madison Avenue. Initially handpainted and then manufactured by an outdoor flag company (Arista Corp.), they were first hung as a way to get out the word about current shows by such artists as James Garvey and Alfred Jensen. The colorful Hard Edge and Pop designs attracted so much attention that Graham, the art consultant/framemaker Barbara Kulicke, and her partner Sonny Sloan formed the Betsy Ross Flag and Banner Company,[4] some months after the strike was settled, to commission big, vibrant, nylon, felt, and canvas flags by other noted artists. Although the banner movement began with the first exhibition of the commissioned works in June 1963 at the Graham Gallery, it did not gain real impetus until The American Federation of Arts toured the exhibition *Banners U.S.A. I & II* from 1963 to 1965, when the new multiple form emerged full-blown from an advertising phenomenon.

While Oldenburg's studio served as a store for art and galleries became art stores hawked by the new banners, the theme of the market, the store, of popular products, and of foodstuffs for sale remained close-at-hand in Warhol's work (his early advertising drawings were available in a trendy store and soda parlor called Serendipity) as it did in Oldenburg's, and in the halcyon days of "pure" Pop (1961–1964) it sang of what Rosenquist called the "land of supermarket plenty and junk."[5] Not only was postwar America awash in images of consumer goods, the images themselves spoke of a vibrant economy headed literally and figuratively for outer space.

As the imagery that would characterize Pop Art multiples coalesced, so did the working practices that would make them possible. In contrast to the lonely isolation associated with the Abstract Expressionist lifestyle, artists emerged who sought out—even prized—the collaborative environment which would be essential to editions. Happenings and installations were aggressively social. New film and dance were co-op affairs, drawing their proponents from across the disciplines. Warhol called his workplace "The Factory"—a studio where he was never without assistants, collaborators, advisors,

helpers, and general hangers-on. But whether the new-wave place of business was dubbed a store or a factory, its defining element was its symbolic identification as a place of commercial exchange, a metaphor for artistic exchange—putting ideas out there to take, ideas conceived and realized in the artist's "factory."

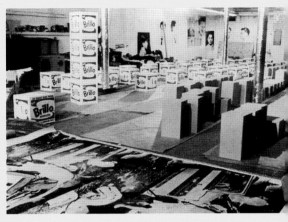

By the end of 1963 the founding Pop artists had been catapulted from obscurity to the frenzied center of "art as a lifestyle—a style dependent on the tension between a private world of creative autonomy and the public demands of the art market."[6] For Dine, Lichtenstein, Oldenburg, Rosenquist, Warhol, and Wesselmann—these artists and others obsessed by the presence of the real, the veracity of the object—who sought to purge art of the rarefied air of abstraction or of signs of the artist's hand, multiples were a natural extension of their philosophy; but it remained for a singular event to ignite the flame.

Andy Warhol's *Brillo Boxes* and *Campbell's Boxes* in the production line at the Factory, ca. 1964
Andy Warhol at the *American Supermarket,* 1964 © Henri Dauman/Dauman Pictures, N.Y.C.

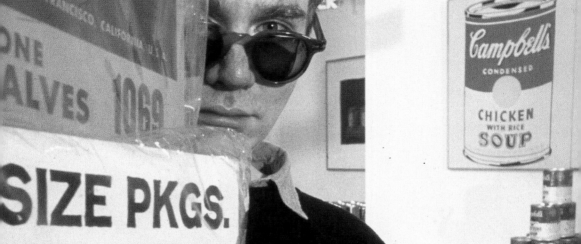

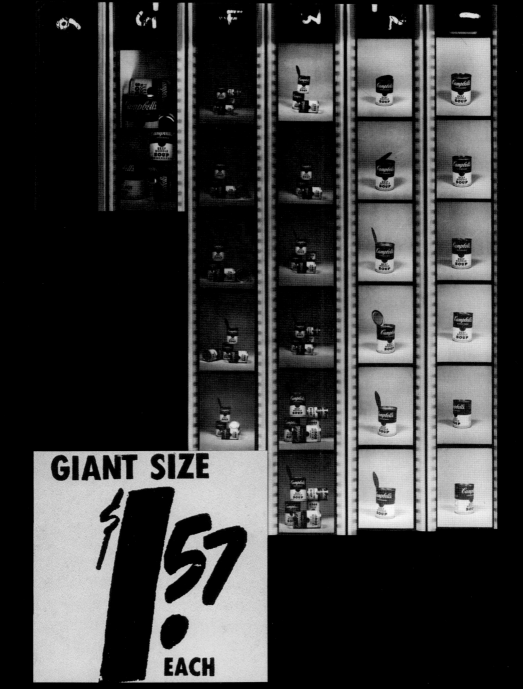

One of several contact sheets of photographs used by Andy Warhol for works in his series of *Campbell's Soup Cans*, ca. 1962

Andy Warhol, *$1.57 Giant Size*, 1963 (cat. no. 80) colors vary within the edition

Walasse Ting and Sam Francis, *1¢ Life*, 1964 (cat. no. 108) © 1997 Estate of Sam Francis
Artists Rights Society (ARS), NY

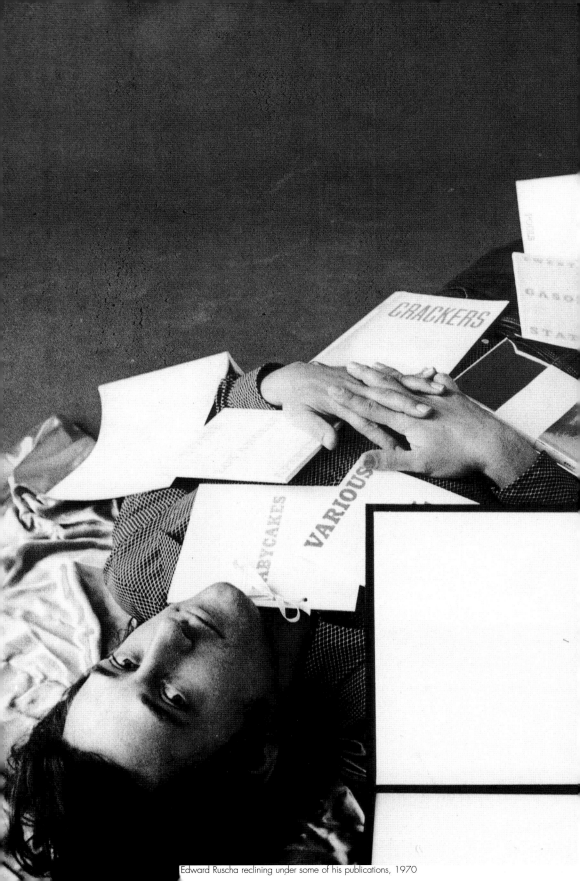
Edward Ruscha reclining under some of his publications, 1970

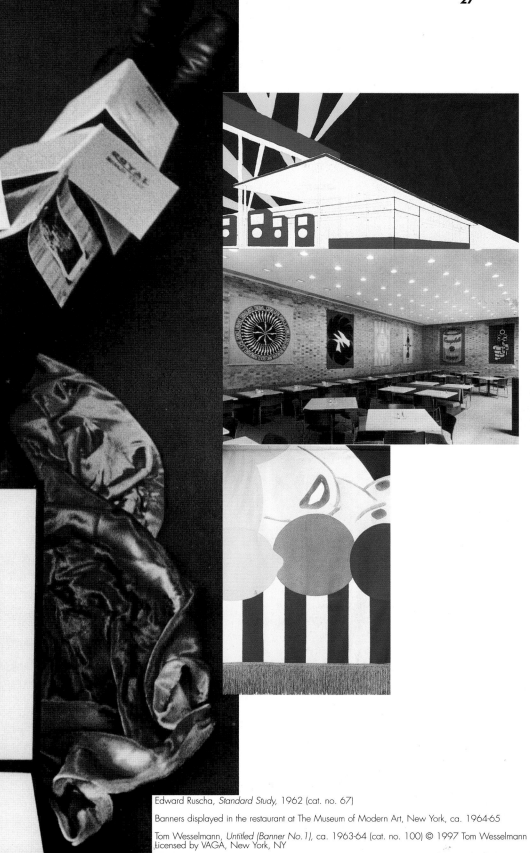

Edward Ruscha, *Standard Study*, 1962 (cat. no. 67)

Banners displayed in the restaurant at The Museum of Modern Art, New York, ca. 1964-65

Tom Wesselmann, *Untitled (Banner No.1)*, ca. 1963-64 (cat. no. 100) © 1997 Tom Wesselmann licensed by VAGA, New York, NY

Roy Lichtenstein, *Pistol* [banner], 1964 (cat. no. 20) © Roy Lichtenstein

James Rosenquist, *Small Doorstop*, 1963-67 (cat. no. 63)

Photographer Ken Heyman's shot of an anonymous Manhattan market featuring a cigarette ad with fingers a la Rosenquist, 1964 © Ken Heyman

II. 1964-1967: Bound, Bagged, and Boxed

If one strand of postmodern culture is art-as-commodity . . . the other is commodity as art. . . .

Simon Frith and Howard Horne
Art into Pop, 1987

When Richard Hamilton coined the term "Pop art" in 1957, he used it to refer not to the emerging visual arts avant-garde, but to the aesthetic qualities—the artful qualities—he hoped to find in mass-produced consumer products. He wrote that they should be:

Popular. . .

Transient. . .

Expendable. . .

Low cost. . .

Mass-produced. . .

Young. . .

Witty. . .

Sexy. . .

Gimmicky. . .

Glamorous. . .

Big Business. . .[7]

Hamilton could easily have been singling out the contents of the *American Supermarket* exhibition held at the Bianchini Gallery, 16 East 78th Street, October 6 – November 7, 1964. The show, the ultimate Happening—although it was not christened one at the time—as organized by artist Ben Birillo, with Paul Bianchini and Dorothy Herzka (Lichtenstein), carried the "store" concept to heights imaginable only to a true Pop Art groupie. It was not about displaying major works by artists who were now suddenly superstars. It was about attitude, lifestyle, and the world of hyper-art events. It was fiction as fact, it was meat and eggs as art. It also demonstrated that Pop multiples—inexpensive Pop objects—would walk right out of the "store" on their own legs.

Two months before the show opened, an unnamed skeptic writing in *Horizon* posited: ". . . Pop Art is nothing if not exterior. It takes the most blatant objects of the outside world and puts them down just as they are, with little attempt to transform them or even interpret them. The danger is that the public may not be able to tell the art from the artifact. . . . We are, in short, pretty close to the moment when some enterprising gallery can exhibit wax ice-cream sundaes and get away with it. . . ."[8] And that, to the delight of the small but giddy "in" crowd, was exactly what Birillo and Bianchini and Herzka did.

Birillo had spent months preparing for the splashy week-long opening. He had lined up Robert Watts, who contributed chrome cabbages, cantaloupes ($125 each), and peppers ($7 each); black and pastel flocked eggs (from $2 each) and bananas; wax tomatoes in gray, white and blue (3 for $15); and plaster loaves of pumpernickel bread. He talked Richard Artschwager into making the turnstile—a sculpture of steel and chrome—while Oldenburg contributed cakes, cookies, and candies. He located Mary Inman—not an artist but a maker of realistic,

American Supermarket announcement, 1964 (cat. no. 107)

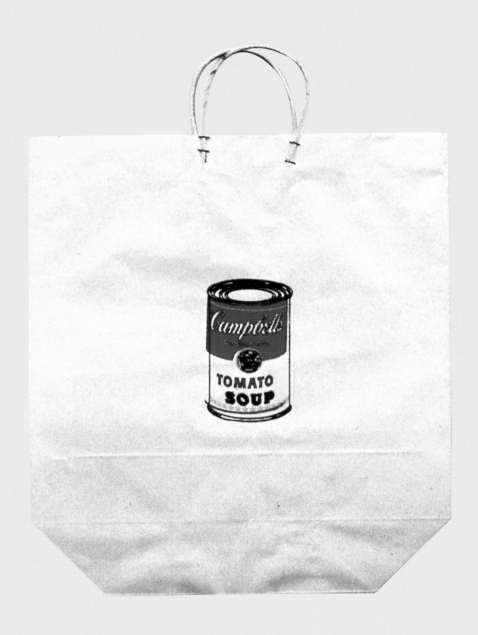

Andy Warhol, *Campbell's Soup Can Shopping Bag,* for the *American Supermarket,* 1964
(cat. no. 83) © 1997 The Andy Warhol Foundation for the Visual Arts/Artists Rights
Society (ARS), NY

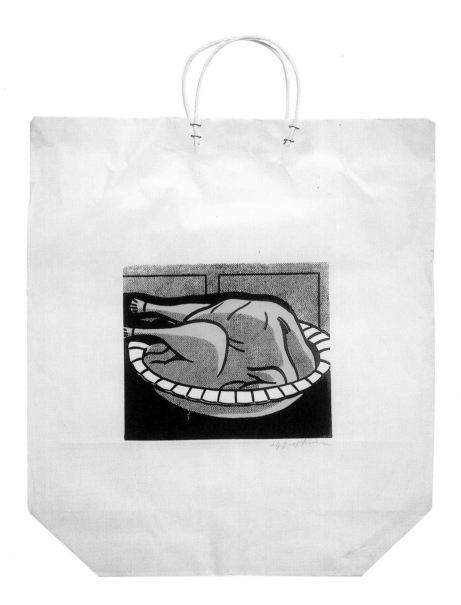

GULF Deluxe CROWN

BUTTERBALL HEADC

Swift's Premium

TURKEY

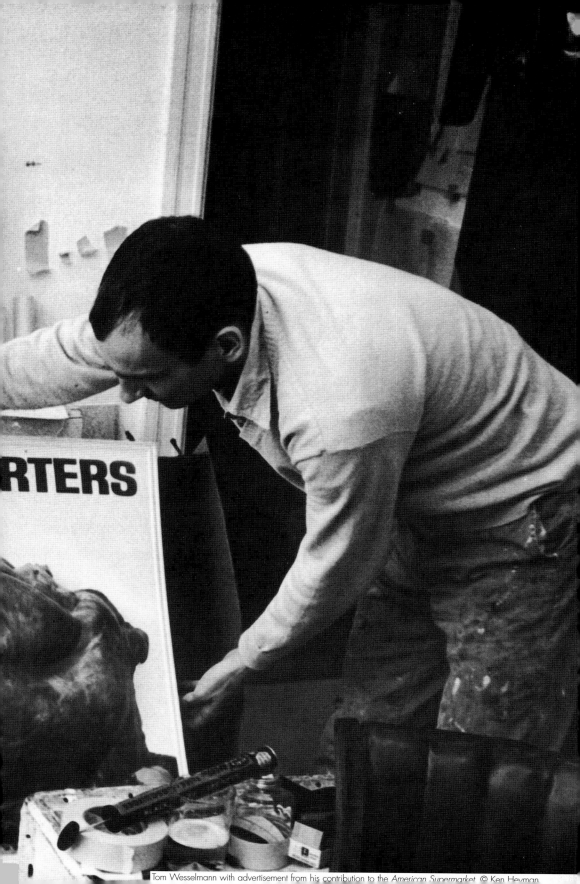

RTERS

Tom Wesselmann with advertisement from his contribution to the *American Supermarket* © Ken Heyman

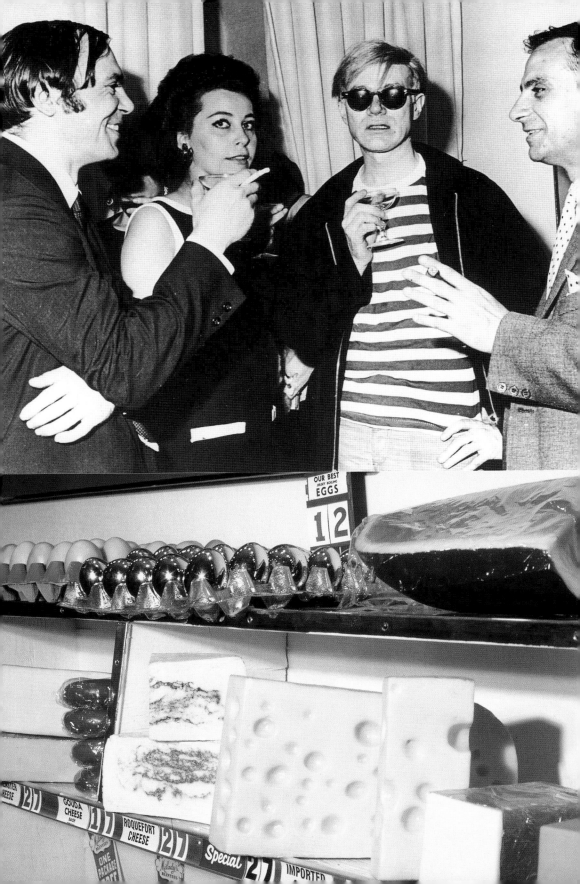

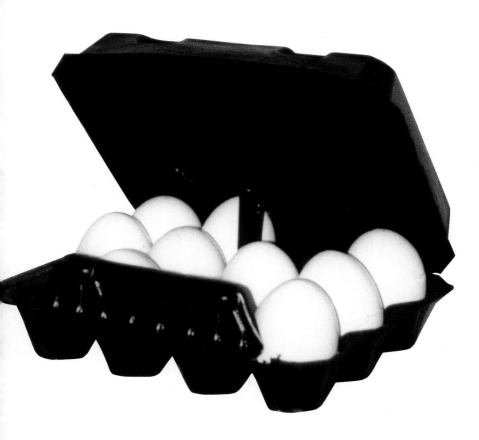

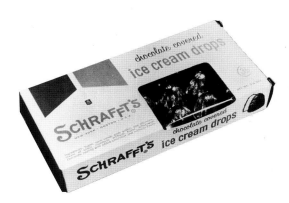

Bob Stanley & guest with Andy Warhol and Ben Birillo at a Bianchini Gallery opening, 1964

Cheese and meats by Mary Inman and eggs by Robert Watts at the *American Supermarket*, 1964
© Henri Dauman/Dauman Pictures, N.Y.C.

Robert Watts, *Egg Box with Eggs*, ca. 1964 (cat. no. 99)

Robert Watts, *Schrafft's Chocolate Covered Ice Cream Drops*, ca. 1964 (cat. no. 97)

The Krashaur living room with paintings by Lichtenstein and Warhol, 1964 © Ken Heyman

Collector Leon Kraushar and his family eating amid "food" art by (left to right): Oldenburg, Warhol, and Wesselmann, 1964 © Ken Heyman

Claire and Tom Wesselmann at Robert Watts' opening, Bianchini Gallery © Peter Moore

handpainted wax foodstuffs for commercial use—and created for her presentation a complete meat case (containing steaks, chicken, a rolled roast, salami, pastrami, and assorted cheeses) destined for the living room of megacollector Leon Kraushar. He secured a 3-D turkey from Tom Wesselmann and he silkscreened the designs of Roy Lichtenstein (a turkey) and Andy Warhol (a Campbell's Soup can) on shopping bags—the hottest selling items at $12—signed by the artists in editions of some 125 each.[9] The parting gift of the evening was boxes of frozen blintzes—real ones, donated by an advertising agency—but the high moment of drama came when the most notorious Pop Art collectors came by to collect their bronze ale cans by Jasper Johns—lent to the exhibit. "'I just don't want people touching them.' Mr. Scull said, as he picked them off a pyramid of genuine Ballantine cans. 'When the gallery makes a protective covering for them, I'll bring them back.'"[10] Both *Life* magazine and *The New York Times* ran pictures of the event: Warhol standing forlornly in the midst of stacked Brillo Boxes (after Birillo) on one hand, and pyramids of real soup cans on the other (initialed, 3 for $18); Mrs. Scull fondling Wesselmann's turkey—and more.[11]

The *American Supermarket* all but signaled the end of the artists' personal involvement with wacky, irreverent productions (Pop had become serious business), and the hip world of Pop Art events, parties, and Happenings was soon transported from New York—albeit greatly diluted—across middle America. In New York, however, the two enterprising women who would go on to create the core of Pop multiples were profoundly influenced by the lessons of the popular shopping bags and the avid affection evidenced by their eager purchasers. While the *American Supermarket* traveled to Rome,[12] Rosa Esman and Marian Goodman, separately, and barely known to each other, began to calculate the leap from works in series and multiple originals to formally editioned prints and objects. Out of their explorations would come the first far-reaching publishing ventures: Esman's Tanglewood Press/Original Editions, and Multiples Inc., spearheaded by Goodman and her partners.

Rosa Esman dates her awakening to the middle of 1964.[13] She notes that, as young marrieds on a budget, she and her husband Aaron (then in their early thirties) had been collecting on a modest scale since 1957–58. They spent their Saturdays "going around to the galleries—Leo Castelli, Betty Parsons, Sam Koontz, Sidney Janis—attempting to see every show in New York by the end of each month." During the same summer that the *American Supermarket* show was gestating, Esman was about to issue her first portfolio, encouraged by her friend Hans Klienschmidt, who was deeply involved in European Dada. He told her that wonderful things were being published in limited editions in Paris and that she should get busy in New York. Rosa did know about Tatyana Grossman's Universal Limited Art Editions workshop on Long Island and felt that, although "silkscreen prints were anathema to Tanya," they were particularly well suited to the brash Pop imagery that had become her passion.

"During the summer of 1964," she recalls, "We bumped into Claes Oldenburg in Paris one hot August day." Over lemonade she asked him if he would participate in creating a portfolio of ten prints by ten artists, including Roy Lichtenstein and Tom Wesselmann. When he said, "sounds great," she began to seek friends who might put in $1,000 each and to line up the other artists. She remembers Jim Dine saying, "Rosa what *are* you going to do with 100 portfolios? Where *are* you going to put them? Who's going to buy them?!" Nevertheless, in three months Rosa Esman was a publisher, with the release of *New York Ten* at the hot price of $95 before January 1, 1965, and $100 thereafter.[14] Fortunately it sold out in six or eight months, but as Esman so rightly observed, "Objects had to happen." Thus *7 Objects in a Box* (published in 1966) was born and ultimately became the cornerstone of Pop multiples:

I found that objects were an important part of going to stores and becoming attuned to seeing things that resembled the Pop Art I saw in galleries. I bought an ice-cream sundae and an iced hot chocolate at Serendipity [wax food replicas]. And I had all that junk out where I could look at it for a little bit, but then I put it away—probably around 1966—because it did confuse the issue. It was fun; it was kitsch; it was an "in" joke—life imitating art—but after a while it got tiresome. You did see the relationships, but there was a difference. Multiples, however, were inevitable. Warhol was making boxes; we were all aware of Duchamp's objects. I just didn't think I could make ten [the number of works established in the earlier portfolios]. I probably approached Claes first, and then I began to worry about how I was going to keep all these things together. I designed the box; I just decided it should be a crate stenciled like crates for shipping art. When we began the projects, I made the acquaintance of Dave Basanow, a great fabricator. He did the Dine faucet as a sand cast and the Oldenburg *Baked Potato*. Each project was a challenge, but the objects the artists gave me were really quite wonderful: Andy's silkscreen, Roy's enamel, Tom Wesselmann's *Little Nude*, all of them!

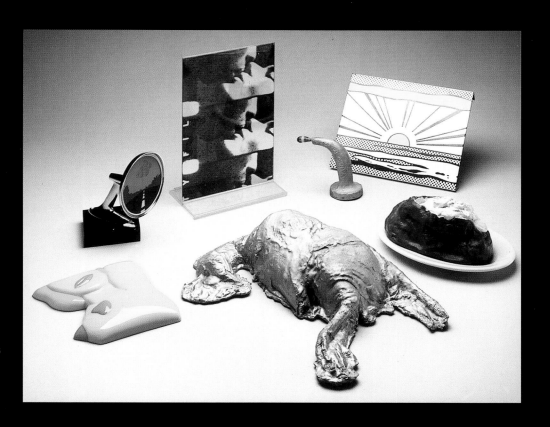

7 Objects in a Box, including works by (clockwise from top) Andy Warhol, Jim Dine,
Roy Lichtenstein, Claes Oldenburg, George Segal, Tom Wesselmann, and
Allan D'Arcangelo, 1966 © reserved to the individual artists and their licensees.

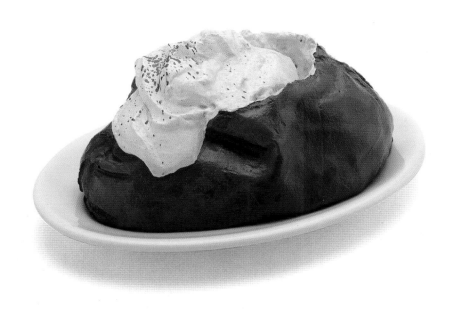

Claes Oldenburg, *Baked Potato*, 1966 (cat. no. 43)

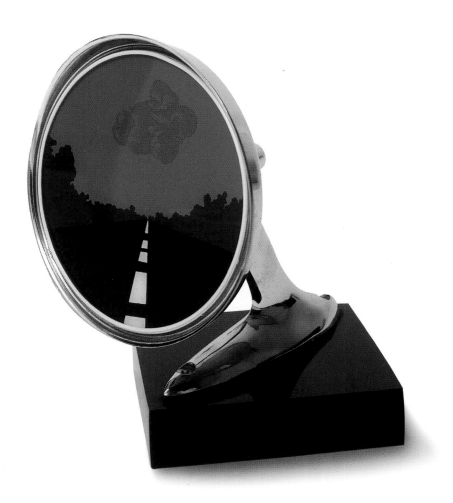

Allan D'Arcangelo, *Side-View Mirror,* 1966 (cat. no. 2)

In addition to producing the first resoundingly Pop, indisputably all-American edition, with *7 Objects in a Box* (edition 75 plus 25 lettered copies) Rosa Esman was, like her counterpart Marian Goodman, enormously influential in sealing the bond between the young artists and new technologies. Multiples, it might be argued, could not have flourished in any city other than New York—a mother lode combining art, commerce, and industry in just the right proportions. Barbara Kulicke found professional flag makers; Billy Klüver used his resources as an engineer (with Bell Labs) to assist the artists in a program he and Rauschenberg later christened E.A.T. (Experiments in Art and Technology);[15] Ben Birillo not only employed his own formidable art skills but also those of the fabricators he sought out on an as-needed basis. Esman and Goodman found it necessary to enlist Robert Kulicke's frameshop personnel and to explore many offbeat byways in order to locate the resources required to realize the technologically advanced concepts the artists presented. Vacuum-form molding, for example, which played such a large role in the early projects, became accessible (in this case, through Robert Kulicke's shop) to the general public only after World War II; plus the incredible spectrum of necessary cottage-industry workshops that also flourished after the war was found in great concentration only in the city.

Among Esman's *7 Objects*, Roy Lichtenstein's *Sunrise* was baked enamel, the medium that had also been sought out by Birillo to realize Lichtenstein's giant hot dog for the *American Supermarket*, and the hard, reflective, color-saturated surface was a perfect foil for his signature Benday dots. Jim Dine's *Rainbow Faucet* was matte-gray metal—tactile and powerfully evocative of the childhood enchantment of his grandfather's hardware store. Tom Wesselmann's curvaceous *Little Nude* glistened ideally in every come-hither vacuum-formed plastic crevice. To realize Alan D'Arcangelo's *Rear-View Mirror*, a freshly minted hardware store model was employed as a reality-check backdrop for his silkscreened reflection. For Claes Oldenburg, an assembly line of friends and associates was gathered to produce the *Baked Potato*. First a plaster master was shaped around a sewn-canvas potato, then the master was used to form the mold for the resin casting. Following explicit instructions, the painter John Wesley laid on the color in prescribed strokes. Finally, Claes himself flipped on the chives with an ordinary toothbrush. As he observed, "How to paint the work seemed to me a critical decision. It should be hand painted like the unique work, but the hand-painting should be removed, objectified in some way in keeping with the work's mass-produced character."[16] These, plus Warhol's Hollywoodish *Kiss* and Segal's fleshy *Chicken*, were evidence of brilliant marriages between idea and process, object and material, unique conception and mass production—a fusion which was and remains the underlying, defining essence of *7 Objects in a Box*.

While the *Supermarket* was being stocked and *7 Objects* molded, baked, screwed, and glued, the most far-reaching multiples marriage—the one that would stamp the genre with a capital M—was at courtship peak. Barbara Kulicke, who had founded the Betsy Ross Flag and Banner Company with Robert Graham, remembers:

> After a year or so *[late 1964]* it became evident that it *[BRFBC]* could not sustain itself as an independent business. By then Sonny Sloan had joined me in my offices in a room in the frame factory. I met with Marian Goodman who was looking for a place and *[the opportunity to create a]* business. Multiple editions of all kinds of art objects using all kinds of materials was the plan. We agreed on MULTIPLES as the name. Ursula Kalish came in with Marian . . . so there were five of us at the beginning of Multiples. A gallery/store on Madison Avenue and 70th Street was opened on the night of the big blackout. The three active partners, Ursula, Marian, and Sonny ran it for several years, producing many extraordinary art objects and changing art history in a small but serious way.[17]

In 1964 Marian Goodman was a graduate student in art history at Columbia when she saw the *American Supermarket* show. She bought shopping bags by Warhol and Lichtenstein and remembers to this day how "very exciting" the show felt to her.[18] "It had a big influence, as did an exhibition of works from Édition MAT at the Museum of Modern Art.

I went from being a graduate student to my first publication in less than two years [by the end of 1965]. Starting Multiples was complicated. I had done a show for Kline and de Kooning at Walden (my children's school), and at a certain point we decided to do a portfolio. Artists really enjoyed the idea of making editions. Although there wasn't much money around at the time, people could buy them easily. I loved working with artists, I had seen Tanya's [Grossman] prints, and my first idea was to try to interest a museum in a publishing program that would be non-profit but self-sustaining. Finally, when The Museum of Modern Art and The Jewish Museum turned me down, I spoke with my friend Barbara Kulicke, who was the only person I knew in the art world. She said, "Let's join forces!" By then Betsy Ross Flag and Banner Company was working with people like Wayne Thiebaud and Jack Youngerman and had already published some twenty or more different banners. Early in 1965 we talked about having a place not only where we could publish, but a place that could, in a sense, be headquarters for all publishing. I think I was most interested in all of the new and different technologies that made it possible to produce the objects.

In a prologue unveiling the timely venture, Grace Glueck wrote in The New York Times that a "new gallery called Multiples will hit Madison Ave. (No. 929, to be exact) on or about Nov. 8 [1965]:

What separates Multiples from the Madison Ave. herd? It will simply have nothing to do with art that's unique. Eschewing traditional, one-of-a-kind paintings or sculptures whose prices are necessarily high—it will handle only multiples—prints, portfolios, posters, jewelry, sculptures, objects, boxes, banners and so forth produced by well-known artists in carefully supervised, signed and numbered editions.[19]

The article noted that Multiples would feature editions from the Betsy Ross Flag and Banner Company (now subsumed by Multiples with an inventory of some 45 banners in projected editions of 20), from Édition MAT in Cologne, from Rosa Esman's Tanglewood Press and Original Editions, and from the Kulicke Cloisonné Workshop, which produced artist-designed jewelry. Finally, it highlighted Multiples' own first effort, Four on Plexiglas—a steal at the pre-publication price of $475 (edition 125). Marian remembers choosing the four artists with Robert Kulicke, who was a friend of Barnett Newman's and of Philip Guston's. Together they

added Claes Oldenburg and Larry Rivers. Kulicke had produced and popularized the revolutionary and very beautiful seamless-plastic wall-box frame developed by Dave Basanow, who once again served as the fabricator, silkscreening the Tea Bag. "Claes made the Tea Bag because the technology was available to him," Goodman recalls:

In other words, many new possibilities were discovered and it was a time when artists were quite interested in experimenting with these strange objects . . . particularly Pop artists, who did these editions so well. They were fun. In the gallery we had a huge wall of bookshelves—it must have been more than twenty-feet long—with glass shelves and niches. And there were all of these objects—the shelves were crammed full. My impression was that people really loved shopping. It wasn't really like a gallery—it didn't have to be taken too seriously.

Multiples' early customers ranged from the eminent Abstract Expressionist and Pop Art collector Emily Tremaine to Goodman's son, who acquired the Castelli Gallery's posters in the $5-$25 range and tacked them to his wall with straight pins—never dreaming they would become icons of the period. Goodman herself spent little time in the gallery, preferring to work with the artists in the publishing process. Much of the original impetus of Multiples was, she says,

. . . very close to the socialist idea that art should be accessible and if art were available to everybody—and price was not an object—then artists would have a huge audience. It was an important concept for me. I absolutely believed it. And it was an idea that was at least interesting to the people I worked with. We all felt that if young people could buy something really beautiful it could change the audience—an audience that had become elitist because the art was so expensive. There was, generally, a sense of breaking away. There was a rebellion against all the values of the previous generation—against the self-consciousness of Abstract Expressionism.

As examples of the utopian notion that unlimited editions might in fact constitute the future of a democratic art, Goodman cites the Modern Head Brooch/Pendant by Roy Lichtenstein and a planned but unrealized lithography project by Jasper Johns. But, very quickly, even she realized that the word "unlimited" was a non sequitur at best. The Lichtenstein brooch turned out to be one of the most difficult

Roy Lichtenstein, *Seascape (II)*, 1965 (cat. no. 23) © Roy Lichtenstein

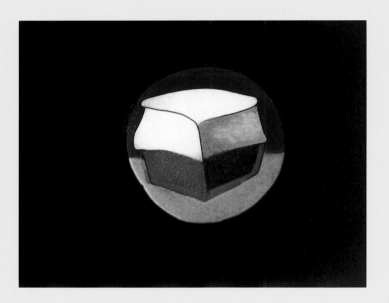

Wayne Thiebaud, *Boston Cream Pie* [pin], 1965 (cat. no. 78)

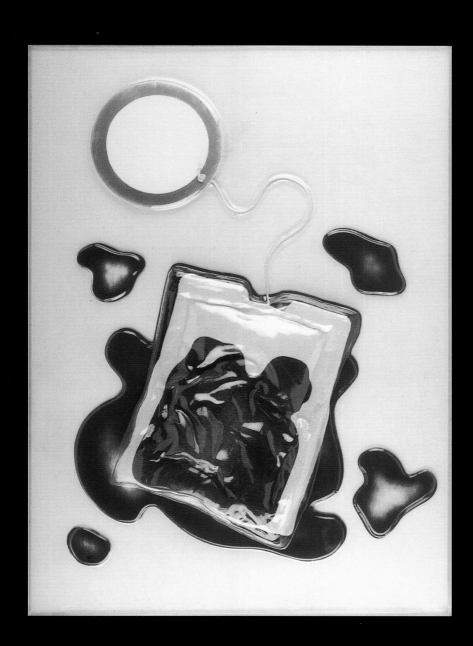

Claes Oldenburg, *Tea Bag*, 1966 (cat. no. 45)

Roy Lichtenstein, *Drawing–Modern Head Pendant,* 1970 (cat. no. 32) © Roy Lichtenstein

Roy Lichtenstein, *Modern Head Brooch/Pendant,* 1968 (cat. no. 33) © Roy Lichtenstein

designs to fabricate, calling for a refined and graphically precise enameling (they hoped would result from an alliance with a seasoned costume jewelry manufacturer) that proved virtually impossible. At least a third of the production was scrapped in the process of quality control. Today the size of the edition (in two color combinations) remains small but unknown.

Certainly Pop multiples (and serial originals) helped instigate the predominance of the concept over the presence of the artist's hand. Their antecedents were Moholy Nagy's paintings ordered over the telephone from a commercial signmaker (a feat replicated in 1962 by Walter Hopps when he needed a poster for one of the earliest Pop Art exhibitions, *New Painting of Common Objects*, at the Pasadena Museum of Art), Marcel Duchamp's Readymades, and Joseph Beuys' (whom Goodman notes "was like a multiples factory") earliest contributions in Europe. But the most memorable aspect of the first blush of Pop multiple objects was an unmistakable Duchampian brand of appropriation. Nowhere else in the world did a trip to the gallery feel like a brush with the hardware store, the market, the dry goods emporium, a bundle of newspaper advertising, and Saturday night in Times Square all rolled into one.

While Warhol either consciously or unconsciously adopted Duchamp's strategy of benign silence, such artists as Rosenquist and Lichtenstein sought out the master. Favorite period remembrances range from trading works of art with him, as Rosenquist did, to his subdued, rear-of-the-auditorium presence at the first public Pop Art symposium at The Museum of Modern Art. Though Duchamp was only one presence in a spectrum of influences that brought about phenomenal change in the late fifties and early sixties, the single attribute of many Pop multiples that signals direct kinship with Duchamp's *The Bottle Dryer*, and its relatives, is ambiguity. Pop artists relished placing their work on that edge between what it appeared to be (seemingly unadulterated anonymous commercial images or commercially fabricated objects) and what it was: the new brand of art that was indelibly theirs. It was the ambiguity—the irony, the paradox, the humor—that gave the works—just as in the case of the Readymades—their resonance, and it was the common objects they appropriated that lent themselves most convincingly to the inspired contradictions.

1964–1967 were the buoyant years, the years of fun and fantasy before the American scene soured in the face of repeated assassinations, race riots, the escalating war in Vietnam, and the Chicago convention debacle. A large (and typically whimsical) number of editions landed in eager galleries—a trickle in 1965 that reached flood stage in 1967. Multiples Inc. became the headquarters of the movement—one more real and metaphorical "store" in the

chain that Oldenburg spawned—and Goodman herself was exhilarated by the collaborative course of the production process:

> I remember doing the *Cigar Box* with Larry Rivers—those cigars with the silkscreen bands. I went to various shops—the model-maker's shop, the silkscreen shop—all on the back of Larry's motorcycle. We'd go through *The Yellow Pages* and start visiting. There were two banner fabricators. The last one, Mr. Greenspan at Abacrome, 18 East 16th Street, was a very volatile man. He had a real sensibility. He did banners which were very difficult to fabricate. The artist would bring a sketch and then Mr. Greenspan would put together the fabrics and create a prototype. I often thought he might have become an artist. When he retired we stopped making banners because it was impossible to find a workshop of equal quality.

The banners—the earliest here Tom Wesselmann's blonde adorned by deliciously bitchy gold fringe so cheerfully flaunting timid taste—were projected as editions of twenty, but were made, with signed and numbered labels affixed, only as they were sold. As numerous labels remain in the Multiples archive (not necessarily in numerical order), it is now virtually impossible to determine how many of any given banner might have been fabricated. Barbara Kulicke initially saw them as alternatives to large, costly (also expensively framed) works destined for public places. Polished aluminum bars, courtesy of Kulicke design, anchored the tops and bottoms, and they were simply rolled and placed in tubes for transportation. The ease of handling was a significant plus, but over time, the felt became a haven for moths and the new vinyls hardened and cracked. Today, a banner that has survived in pristine condition is a rare commodity.

Other editions which marked the escalating craze were Roy Lichtenstein's graphic black and white china by the Durable Dish Company; the Kulicke cloisonné jewelry, which included pins and pendants by Lichtenstein and Wayne Thiebaud; Rosa Esman's second object-oriented portfolio, *Ten from Leo Castelli;* Oldenburg's *Wedding Souvenir* created for the Los Angeles wedding of curator James Elliott; Warhol's flamboyant *Cow* wallpaper; and the ongoing, highly enigmatic book editions by Ed Ruscha.

By the mid-sixties, it seemed the whole country was beginning to see the world through the colorful lens of the Pop phenomenon. *Newsweek* crowed:

> It's a fad, it's a trend, it's a way of life, it's pop. It's a $5,000 Roy Lichtenstein painting of an underwater kiss hanging in a businessman's living room. It's a $1 poster of Mandrake the Magician yelling, "Hang on Lothar! I'm coming!" taped on a college-dorm wall. It's 30-million viewers dialing "Batman" on ABC every week. It's "Superman" zooming around on the Broadway stage attached to a wire, while the sophisticates in their $12 seats are carried back to childhood. It's a POW! Bam! commercial for Life Savers on TV and a huge comicstrip billboard for No-Cal glaring down on Times Square. It's lion-maned Baby Jane Holzer in a short-skirted wedding dress. It's the no-bra bra and the no-back dress. It's Andy Warhol's new nightclub, The *[Exploding]* Plastic Inevitable, where three movies flicker simultaneously and a man lifts bar bells to a rock beat.[20]

In the hinterlands Pop reigned as well. "Camp" came to places like Kansas City "when costumed revelers—the Caped Crusader and Robin, the Boy Wonder," among them—assembled in a "strange melange of the far-out, the madly 'in,' the hip and the curious" for the "midwestern underground film premiere of Andy Warhol's *Lupe* starring Edie Sedgwick. . . . The evening as programmed by UNIVAC 1004 . . . consisted of beer, frugging, do-it-yourself underground movies . . . plus a continuous showing of . . . *The Maltese Falcon.* . . ."[21]

For dedicated shoppers, art was over-the-counter, as department stores joined the ranks of tongue-in-cheek stores and store-front galleries. *Time* observed that "originals can now be sold along with paint or panty girdles."[22] On a more serious note, dealer Richard Feigen briefly stocked a multiples outlet in New York's upscale Bonwit-Teller store. By the fall of 1967, some were ready to call a halt to it all. In the *National Review* Ruth Berenson proposed that the shock appeal was gone:

> Now only five years later *[1962-1967],* Pop seems happily to have run its course. . . . Andy Warhol hasn't painted a soup can in years. . . . Pop furniture is made in Grand Rapids; Pop dresses . . . now adorn teeny-boppers in Middletown and Gopher Prairie."[23]

The year of "flower power" and the "summer of love," however, harbored one final fantasy art store: *The Museum of Merchandise.* Held at the Young Men's/Young Women's Hebrew Association (sponsored by its Arts Council) in Philadelphia, it was the most inventive, if totally daffy, event conceived by the indefatigable duo, Audrey Sabol and Joan Kron. On the outskirts of the sixties art scene geographically, but never intellectually, together they had been making waves since 1962, when they enlisted Billy Klüver to spearhead the exhibit *Art 1963—A New Vocabulary* (October 25–November 7, 1962), the first important Pop/Fluxus show held outside of New York.[24] By 1963 they had founded the Beautiful Bag Co. (canvas totes carried by artworld mavens), which was soon followed by spinoffs that would include, the Beautiful Bag and Box Co., the Durable Dish Co. (for Roy Lichtenstein's china), the Rare Ring Co., and other businesses designated by mellifluous names they dreamed up for their Pop products and multiples. By far their most ambitious project was the Happening/store/event/exhibition they called *The Museum of Merchandise.* The *Philadelphia Bulletin* said it was a "switched-on, tuned-in, op-pop, electronic event," the purpose of which was to exhibit consumer goods designed by artists. Joan and Audrey had spent months trying to talk various manufacturers into producing artists' designs—such designs as Geoff Hendricks' white clouds floating on pale blue sheets and pillow cases (ultimately hand-painted on window shades; 3 at $250 each), only to be told tartly by Spring Mills that "sheets printed only with clouds do not provide us with enough scope for merchandising."[25] Undaunted, they viewed the show as a dry-run, a marketing test for artist-designed goods that could be economically manufactured and widely distributed among a theoretically enthusiastic general populace.

Multiples for sale in *The Museum of Merchandise* included the now-notorious perfume "You're In" or "Eau d' Andy," presented in silver Coke bottles by Andy Warhol, until the Coca Cola Company ordered him to cease and desist patent infringement ($10 each); Lichtenstein's "Durable" *Dishes;* ten crates of eggs with silver, vacuum-formed plastic cartons by Bob Watts ($10 each); not to mention a mammoth, unique wedding dress by Christo, consisting of a two-piece white satin bathing suit and a train—200 square feet of balled-up satin—attached by 400 feet of rope. Plus, in the midst of it

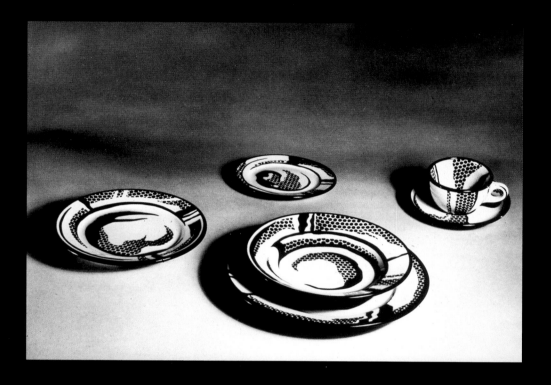

Roy Lichtenstein, *Dishes*, 1966 (cat. no. 26) © Roy Lichtenstein

Robert Rauschenberg, *Passport*, 1967 (cat. no. 60) © 1997 Robert Rauschenberg/Licensed by VAGA, New York, NY

James Rosenquist, *Sketch for Forest Ranger*, 1967 (cat. no. 64) © 1997 James Rosenquist/Licensed by VAGA, New York, NY

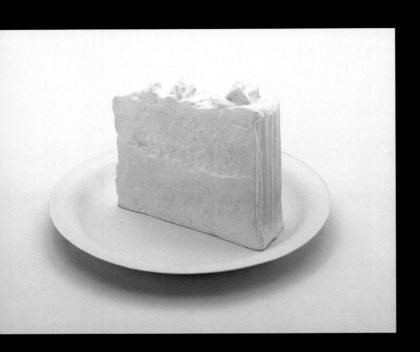

Claes Oldenburg, *Wedding Souvenir*, 1966 (cat. no. 47)

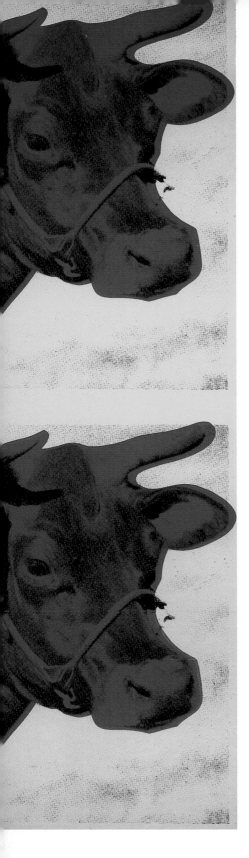

Andy Warhol, *Cow* [wallpaper], 1966 (cat. no. 90) © 1997 The Andy Warhol Foundation for the Visual Arts/Artists Rights Society (ARS), NY

Tom Wesselmann, *Seascape (Foot)*, 1967 (cat. no. 104) © 1997 Tom Wesselmann/Licensed by VAGA, New York, NY

The Museum of Merchandise organizers Joan Kron and Audrey Sabol, founders of the Beautiful
Bag and Box Co., 1965

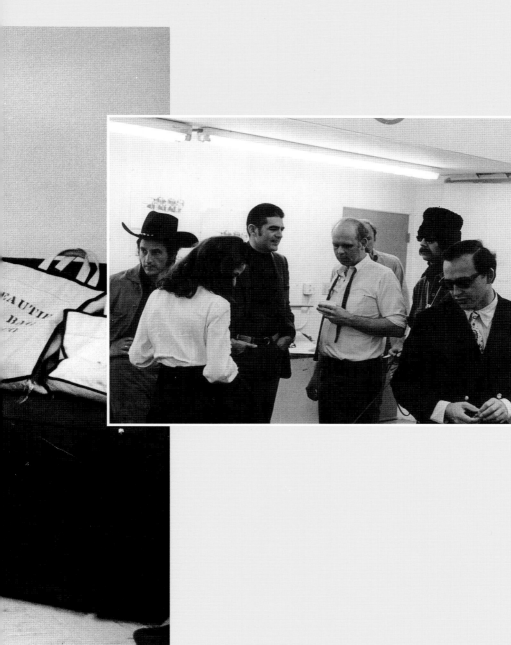

Edward and Danna Ruscha, Irving Blum, Claes Oldenburg, Craig Kauffman, Ron Davis, and a guest at Claes Oldenburg's *Airflow* party, Gemini G.E.L., ca. 1969

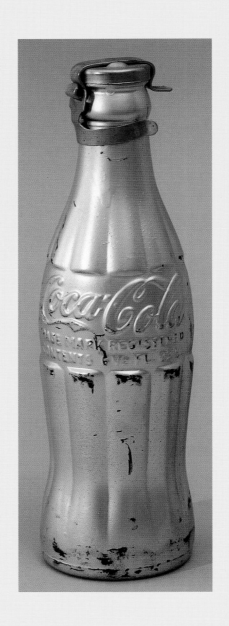

Andy Warhol, *Silver Coke Bottle*, 1967 (cat. no. 92) © 1997 The Andy Warhol Foundation for the Visual Arts/Artists Rights Society (ARS), NY

THIS IS A MUST!

The Museum of Merchandise

Arts Council, YMHA, 401 S. Broad St., Philadelphia

GRAND OPENING...May 10, 1967

GOING OUT OF BUSINESS... May 28, 1967

YOUR BIG CHANCE

A depARTment store.
Operated by the Arts Council of the YM/YWHA.
401 South Broad Street, in downtown Philadelphia.
An exhibition of consumer goods designed and
adapted by the artist for the collector . . .

works of art that have a functional application.
A project of the Fine Arts Committee of the Arts
Council. Conceived and produced by Audrey Sabol
and Joan Kron, based on an idea by Marshall McLuhan.
An event of the Philadelphia Arts Festival.

What's New for the ... home

ODD DINING ROOM PIECES:
Parallelogram Table — Designed by Dean Fleming
Executed by Metalstand Co.

ODD LIVING ROOM PIECES:
Inflatable chair — Phil Orenstein for Mass Art
Table — Pistoletto
Transparent Tables — Susan Lewis
Lit-sits and stands (3 piece set) — Pete McClanahan
Perch — Zabado
Variable Ledge — Lloyd Hamrol
Weather-proof paper table — Frank Viner
with Mead Paper
Love-seat — Bill Accorsi
Profile pillows — Irwin Fleminger
Plastic pillows — Mass Art
Chair — Clement Meadmore
Stools — D'Arcangelo

ODD BEDROOM PIECES:
Canopy bed — Jean Linder
Dressing room — Richard Serra
with complete Uniroyal wardrobe by
Nancy Graves

LAMPS:
Table lamp — Lila Katzen
Chandelier and Sconces — Chrystya Olenska
Door-stops — Jim Rosenquist
Odd lamp — Billy Apple

MIRRORS:
Mirror and hat-rack combination — Jason Seley
Mirror — Chrystya Olenska

LINENS:
Space sheets and pillowcases — Geoff Hendricks
Matching windowshades with the cooperation of
the Windowshade Manufacturers Assoc.
Dreamy pillowcases — Antanakos
Enigmatic napkins — Bill Wiley

FLOOR COVERINGS:
Carpet corner — Richard Anuszkiewicz
custom-tufted by Lees Carpets
Lead rug — Bill Allan
Paper tiles and paper rugs — Betty Thompson
Road-runner — D'Arcangelo
Camel rug — Nancy Graves

HOUSEWARES:
Dish sponges and tea-caddy — Clay Bailey
Dishes — Roy Lichtenstein
made by the Durable Dish Co.
Coasters — Anuszkiewicz
Coasters — Milton Glaser made by Scrabacaus
Egg crates — Bob Watts
Prism glasses — Chuck Ross, Molded by Lurex
Glass Co.
Bird-cage — Mimi Gross
Litter-basket — Arman
Wedges (the disposable experience) — Les Levine
Ash-tray — Jason Seley
Measuring sticks — Will Insley

ART:
Disposable Art — Les Levine

SALE OF THE YEAR!

MUZAK — "Music to buy by" Composed by Steve Reich
with the voices of the contributing artists.

STORE FRONT — Designed and built by Christo.
(Commissioned by Kahn's Furniture Store)
Windows of Plexiglas

STORE INTERIOR — "White Foam", (a disposable place)
created by Les Levine.
Foamed in place by Mr. Robert Engle of the
Weatherking Foam Corp.
Floored in "Topside", the new outdoor carpet
by Lees.

SALESLADIES SASHES — Designed by Robert Indiana

SPORTING GOODS:
Sunfish sailboat from Abercrombie and Fitch
with custom sail designed by Larry Zox,
sewn by Ratsey and Lapthorn
Pool-toy — Jim Melchert

GARDEN DEPT.:
Rocks and boulders — Clay Bailey
Artificial flowers — Antonakos, Bob Arneson,
Mimi Gross
Cabana — Peter Forakis
Playground sculpture — Eric Orr

STATIONERY:
Moving paper-weight — Bob Breer
Writing paper — Bici Hendricks and June
Hildebrand
Post-cards — Geoff Hendricks
Punctuation cards — Bici Hendricks
Conscience cards — Rauschenberg

BOOKS AND RECORDS:
Books — Ed Ruscha
Records — John Giorno and Allan Kaprow

SPRING FASHION opening

**SMART FASHIONS
BY THESE TOP NAME ARTISTS**

Billy Al Bengston — manufactured by
Bates Industries
Christo — hand-wrapped
Paul Harris — based on Capezia leotites
Kusama — custom-made
Marcia Marcus — based on Kleinerts water-proof
head covering.
Chrystya Olenska — made for I. Miller
Phil Orenstein — made inflatable by Mass Art
Michael Oster — a delicacy
Karl Rosenberg — carried out and carried in by
one of the Haight-Ashberry tribes.
Frank Viner — home-made
Wes Wilson — based on Warner's body-stockings.
Phyllis Yampolsky — ready-made by
Abattoire Supply Co.

TOILETRIES:
Toilet water — "You're in" by Andy Warhol

BOUTIQUE:
Cedille box — Dick Higgins
Ties — Clay Bailey, June Hildebrand
Jewelry — Marisol, Tamara Melcher, Chrystya
Olenska, Ruth Sansegundo
Buttons — Jim McWilliams
Sunglasses, helmet and belt — Phyllis
Yampolsky and Herb Gesner
Jewelry box, shoes and hand-mirrors —
Chrystya Olenska

PICK A GREAT CAR BUY!
...you can't miss Here!

AUTOMOTIVE DEPT.:
Painted bodies — Dean Fleming designs
executed by Keenan Motors

CANDY

Edible-disposables — Les Levine
Fillings from the Letty Lane Candy Co.
Vended from a Pennbrook Milk Machine

NEW

CREDITS:
Polyurethane Foam from Napco Chemical
Gallery construction by Lou Rudolphi
Electrical consultants — Sylvan Electric
Work-in-progress photos taken by Paul
Baumann
Slide-projectors loaned by Rosenfeld,
Gilbert and Ring and the Living Arts
Theatre.
Trucking by Quaker Storage Co.
Outdoor sign — Margulis Sign Co.
Shopping-bag idea by Jim McWilliams
Credit-cards printed by Silk-Screen Service
Type — Set by Ad-Comp
Printing by Mid-City Press
Special thanks to Bill Brooks and Jim
Crawley of the Y.
Assistant to Christo — Judy Lieb
Cooperating galleries:
Multiples, Castellane, Kornblee
This exhibition could not have taken place
without the help and encouragement of the
Board of the YM/YWHA and the cooperation of
the staff.

**Arts Council Committee
for Museum of Merchandise**

Audrey Sabol — Chairman Fine Arts Committee
Joan Kron — Chairman Arts Council
Mrs. William Drutt
Miss Miela Gallob
Mrs. Herbert Kane
Mrs. Robert Kardon
Mrs. Willard Keiser
Mrs. Nathaniel Lieb
Mrs. M. H. Samits
Mrs. Lester Schafer
Mrs. David Snyder
Mrs. Herbert Stanton
Mrs. Harold Wilf
Mrs. William Wolgin
Mrs. Howard Yusem

Louis J. Gaffman
President JYC
Howard Adelstein
Executive Director JYC
I. Jerome Milgrim
President YM/YWHA
branch JYC
I. Tennenberg
Director, YM/YWHA
branch JYC
Mrs. Joseph Ostrow
Director, Arts Council

The Arts Council is sponsored by the YM/YWHA,
a branch of Jewish Y's and Centers
of Greater Philadelphia.

EXCITING VALUES

and the Slant-step.

NEVER BEFORE!

This list is bound to be incomplete.
All purchases final; no merchandise may be
removed until pick-up date of May 28.
No C.O.D.'s. Mail and phone orders accepted.

The Museum of Merchandise poster, 1967

all, far-out fashion designer Tiger Morse did an "artsy" striptease as part of her talk about fashions designed by artists. The exhibition was covered by *The New York Times,* and Joan appeared on the Johnny Carson show with many of the items. Was it possible that the crazy carousel—the "popular" in Pop—was beginning to spiral out of control?

III. 1968-1970: Good-bye Innocence

In 1968 *The New York Times* announced the death of Pop Art and, within months, a novel hallmark of the era disappeared . . . : the Pop Art lifestyle. Warhol had *[first]* set the tone during the *[early]* Factory years in New York, followed by endless nightly appearances with his entourage at Max's Kansas City, and . . . by the debut of "The Silver Dream Factory Presents the Exploding Plastic Inevitable with Andy Warhol/The Velvet Underground/and Nico" at the Dom disco on St. Mark's Place. The mood *[was]* party. In lofts around Manhattan the various merits of the Beach Boys and the Beatles were hotly debated until the "Motown Sound" drowned them out. . . . Courrèges boots and Pop-pattern Mondrian mini-dresses were rampant. . . . With an eye to Pop subject-matter, collections of American advertising ephemera, from Coke trays to Mickey Mouse, were assembled, hostesses set out Thiebaud displays of buffet food and papered their bathrooms with Warhol cows. It all jolted to a halt that week in June 1968 when Robert Kennedy was assassinated in Los Angeles (Tuesday, 4 June) and when Valerie Solanas marched into the Factory (Monday, 3 June) to fire the shots that put Andy Warhol on the front pages he might once have appropriated.[26]

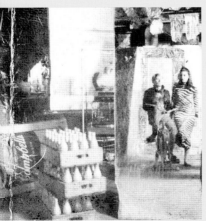

Joan Didion (whose *Slouching Towards Bethlehem* remains the diary of the period) remembers the late sixties as "a period of high anxiety. 1968 was really a heated year," she says. "The whole country seemed to be breaking apart."[27] Journalist James R. Carroll used the same words— "breaking apart"—in an August 25, 1996, report from the first Democratic convention to be held in Chicago since that ugly summer. The decade born in optimism now waned in blood. Carroll remembered:

> A week after Kennedy was buried. . . . The nation's capital was in turmoil. National Guardsmen stood with fixed bayonets on street corners along Pennsylvania Avenue. There were looting and fires downtown and in the city's African-American neighborhoods. Down along the reflecting pool leading to the Lincoln Memorial a sea of tents called Resurrection City had sprung up, as the poor and disenfranchised demanded action from President Lyndon B. Johnson. And the Vietnam War was raging. . . . Then Chicago. . . . In what a federal commission later called a police riot, anti-war protesters were bloodied by billy clubs and tear-gased . . . while demonstrators chanted "The whole world is watching! . . ." Our nation had become angry, violent, divided.[28]

As America underwent profound change, so too did the artists. The decade shoved them onto the fringes of middle age, saw them catapulted from obscurity to stardom, and fractured whatever joinings might have held them close in Pop's formative years, as each followed his own dreams and confronted his own demons. Dine abandoned America for Britain and a London life steeped in poetry, books, and prints. Rosenquist became ever more enmeshed in the social politics of the environment and his oblique commentary on its endangerment. From the moment of the first monument proposals in 1965, Oldenburg began to cast off the funky, happy-hands-at-home posture that characterized *The Store* and direct the theatrical aspects of his work away from staged events toward the colossal sculptures that would begin to pepper his landscape in the seventies. In Lichtenstein's ouevre "Pow!" and "Blam!," "Zing" and "Bwee!" were replaced by an almost minimalist examination of art forms and art history—mirrors, architecture, Art Deco motifs. Warhol, the way Calvin Tomkins put it, "kept his cool [after the 1968 Solanas shooting], but things are not the same. . . . At the new Factory down on Union Square, Andy's friend and business manager Paul Morrissey has more or less taken over the Warhol films operation. Andy comes in for an hour or so each afternoon but his heart is not in it. . . . At the moment . . . what we

Andy Warhol with an unknown woman reflected in a mirror at the Factory; a vintage print from The Archives of The Andy Warhol Museum showing coke bottles in progress for *The Museum of Merchandise,* ca. 1966-67

Party goers wear Warholian garb, 1964 © Ken Heyman

Claes Oldenburg, *Fire Plug Souvenir - "Chicago August 1968,"* 1968 (cat. no. 56)

Claes Oldenburg, *Nose Handkerchief*, 1968 (cat. no. 54)

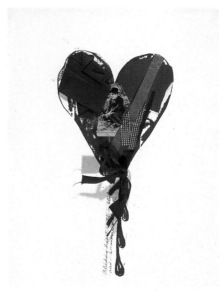

Jim Dine, *Pallette II*, 1969 (cat. no. 11)

Jim Dine, *Bleeding Heart with Ribbons and a Movie Star*, 1968 (cat. no. 6)

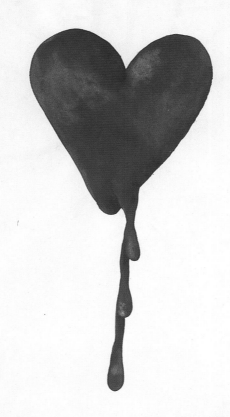

Jim Dine, *The Picture of Dorian Gray (Study for Dorian Gray Poster)*, 1968 (cat. no. 7)

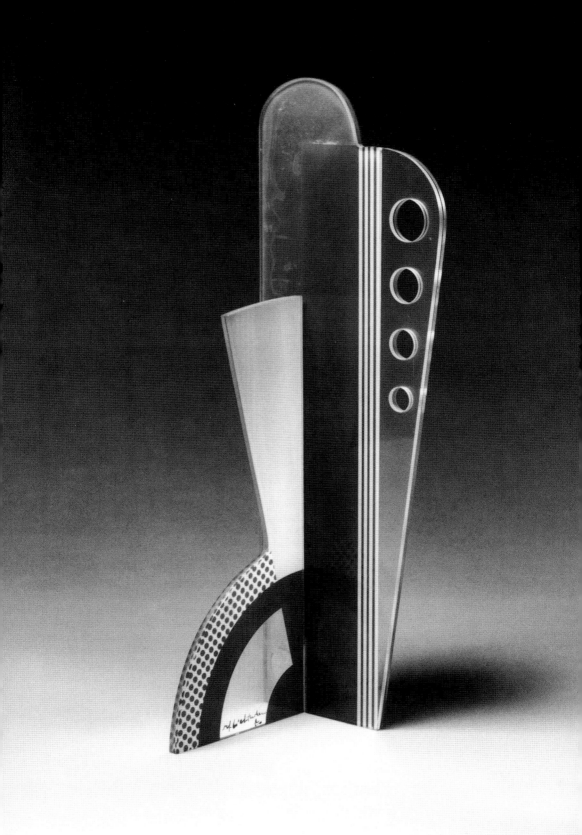

Roy Lichtenstein, *Modern Sculpture with Apertures*, 1967 (cat. no. 27) © Roy Lichtenstein

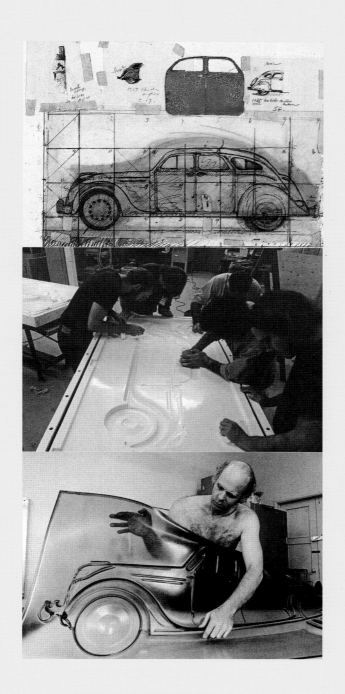

Claes Oldenburg, *Profile Study of the Airflow*, 1965

Claes Oldenburg, Kenneth Tyler, and the staff at Gemini G.E.L. polishing the *Profile Airflow* acrylic mold at H & H Tooling, Los Angeles, 1968

Claes Oldenburg working on *Profile Airflow* project, 1968

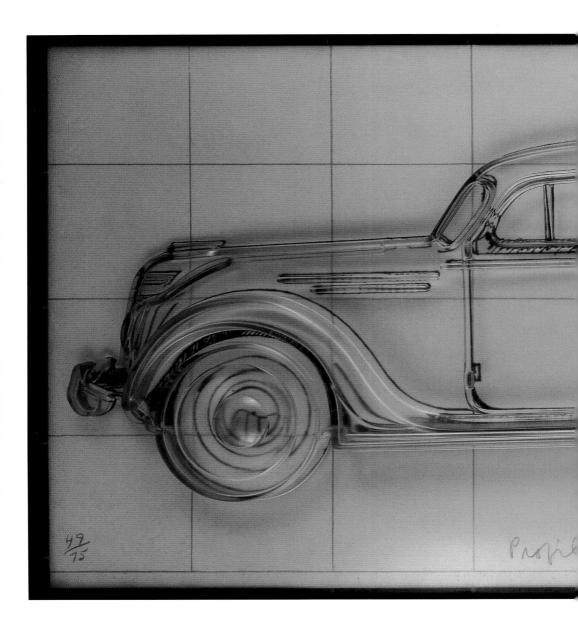

49/75

Profil

Claes Oldenburg, *Profile Airflow*, 1969 (cat. no. 57)

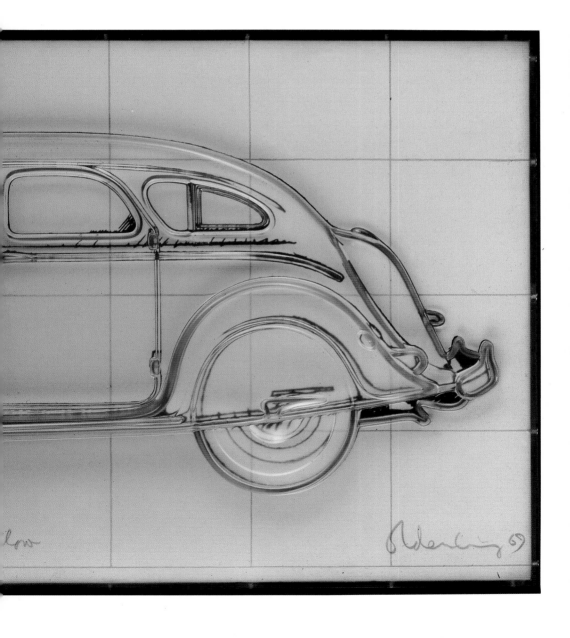

see reflected in that strange face is a sickness for which there may be no cure."[29] Finally, Wesselmann focused on expanding and refining the still life compositions and the female/erotic imagery introduced in the *Great American Nude* series. Going their separate ways in an art-boom climate that had made theirs household names, they were far too much in demand to use time in the seemingly playful, obviously ebullient mode of 1964.

In a moment of parallel expansion and radical change, America—thanks to pioneers like Goodman, Esman, and Tanya Grossman—was on the verge of a great printmaking explosion that had imbedded within it an intensified commitment to the utilization of highly complex and rarefied industrial/mechanical technologies in the service of the artists' most extravagant dreams. In this image, Gemini Ltd. was founded in Los Angeles in 1965 by Kenneth and Kay Tyler, and in 1966 rechristened Gemini G.E.L. with the arrival of partners Stanley Grinstein and Sidney B. Felsen. In the world of high-tech editions, the title of Gemini's first important exhibition at New York's Museum of Modern Art was not incidental: *Technics and Creativity* (1971). It was triggered perhaps, in part, by Claes Oldenburg's enormously complicated *Profile Airflow*, which would effectively close the door on the innocent, infectiously droll world of sixties Pop multiples—just as his *Store* had opened it. "The roster of specialists who participated in the experiments to develop the perfect process for accomplishing the plastic shell [of the *Airflow*] included the elite of the Southern California's plastics industry."[30] It was said that the fabrication cost was well in excess of $200,000. Whatever the exact sum, Gemini made technological as well as art history, and the context within which multiples would continue to exist was changed irrevocably. The stakes, now, were high.

By 1970, when curator Donna Stein gave the title "Popular Mechanics in Printmaking" to an essay for the Museum of Modern Art's *Pop Art Prints, Drawings and Multiples* show, and observed that the artists were "interested in the social implications of a more widely distributed art," critic Peter Schjeldahl snapped back in *The New York Times* that she took "a rosier view of the present relationship between the artist and the art market than is perhaps justified by the facts."

One scarcely regrets the stepped-up production of beautiful prints and multiples, but it seems necessary to point out that the relevant "social implications" here are those of a tight-money economy in which fine art has come to impress a great many cautious middle-class types. These adventurous new collectors, since they can't afford a Stella, would rather bank on an expensive print by a big name than a relatively cheap painting by a struggling unknown. The idea of the "precious" object has perhaps been devalued to fit the precarious state of the trade.[31]

Precarious maybe, but the trade became frenzied as the sixties ended. The British magazine *Studio International* devoted annual issues to multiples, which included directories of the publishers, as did *Art and Artists* (beginning in 1969); *Art in America* began a periodic multiples roundup featuring "Art Under $500" (May 1970); John Gruen observed in *New York* magazine (April 1970) that "as far as art dealers are concerned multiples constitute the fastest growing market both in this country and abroad."

Many of the Pop multiples produced in the last years of the decade were distinguished by as congenial a balance between art and technology as any visionary might have imagined: Oldenburg's soft, skinlike *London Knees*, extraordinarily difficult to realize, were captivating; Lichtenstein's stunning *Modern Tapestry* was as fine as those of any period in history; Samaras' brilliant book/object with its elaborate die-cutting stood in relief, more than sending the message of the power of his boxes it resembled; Rosenquist's *Baby Tumbleweed* became the painter's most evocative and sought-after object. On Manhattan's Upper West Side the American Surrealist painter William Copley established S.M.S. studios in 1968. A member of the wealthy media-empire family, Copley used his fortune to place every option in the hands of such artists as Lichtenstein, Oldenburg, Duchamp, Artschwager, John Cage, Christo, and Man Ray, so that they might create six tiny but remarkable S.M.S. portfolios over the course of the year.

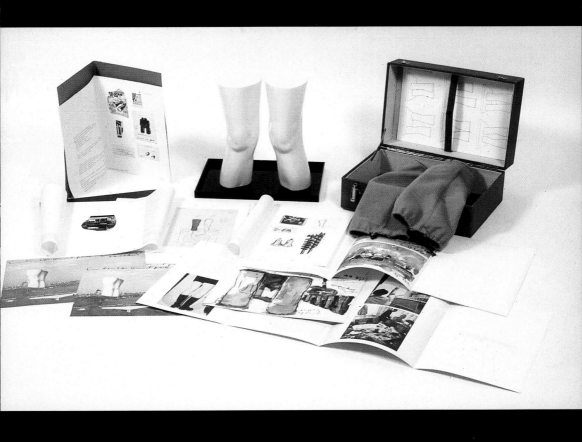

Claes Oldenburg, *London Knees 1966*, 1968 (cat. no. 52)

Lucas Samaras, *Book*, 1968 (cat. no. 74)

James Rosenquist, *Baby Tumbleweed*, 1968 (cat. no. 65) © 1997 James Rosenquist/Licensed by
VAGA, New York, NY

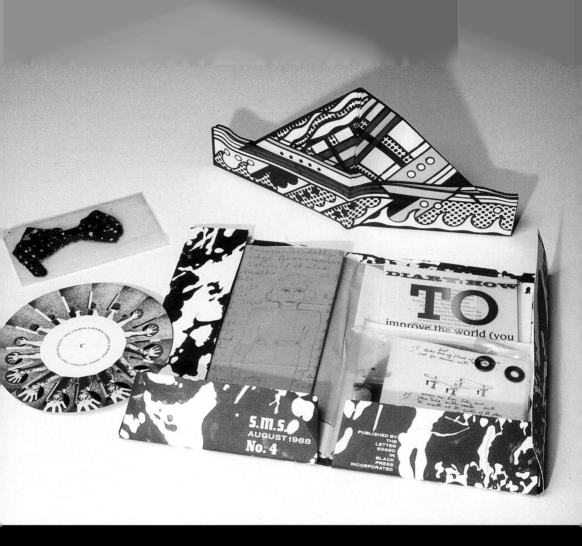

A model demonstrates vinyl stick-on tattoos produced by Robert Watts, 1967

Bert Stern's store, On 1st, by the photographer himself, ca. 1968-69

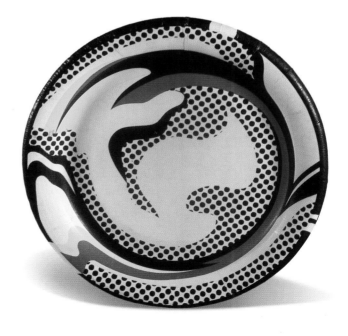

Roy Lichtenstein, *Paper Plate*, 1969 (cat. no. 41) © Roy Lichtenstein

Roy Lichtenstein, *Study for Wallpaper*, 1968 (cat. no. 37) © Roy Lichtenstein

Bert Stern's On 1st with art "products" including *Wallpaper* by Lichtenstein, ca. 1968-69

Roy Lichtenstein, *Wallpaper,* 1968 (cat. no. 38) © Roy Lichtenstein

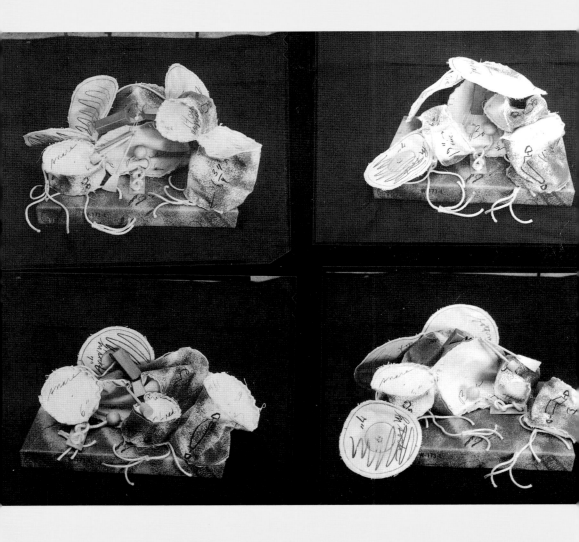

Proof sheet showing four views of Claes Oldenburg's *Miniature Soft Drum Set*, 1969 (cat. no. 59)

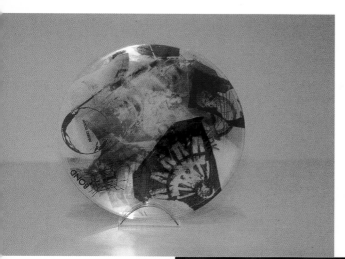

Robert Rauschenberg, *Revolver,* 1969 (cat. no. 61) © 1997 Robert Rauschenberg
Licensed by VAGA, New York, NY

Jim Dine, *Landscape Screen* (5 panels), 1969 (cat. no. 12)

> Each of the six portfolios bulges with . . . texts or images or combinations of the two . . . *[that]* give us intimate proximity to aesthetic intentions. Even accidents were preserved with extraordinary fidelity. Having completed a drawing for *S.M.S.* No. 6, Richard Artschwager happened to splash it with coffee. Instead of removing the stains, he preferred it to be reproduced stains and all, with results that show at full, ironic force the delicacy—and bluntness—of Artschwagerian wit. The visionaries of Constructivism, de Stijl, and the Bauhaus used technology as a springboard to a realm unencumbered by accident or artist's touch. They defined Utopia as individuality transcended. *S.M.S.* defined it as individuality enhanced.[32]

Finally, in 1968–70 one last "store" traveled like a briefly bright comet across the multiples horizon. First the soda-shop gallery, Serendipity, and then the trendy women's clothing store that sold the Robert Watts' tattoos, Paraphernalia, had invented themselves as model Pop lifestyle emporiums. Now, On 1st, fashion photographer Bert Stern's "superstore for art as objects" at 1159 First Avenue was a plea for putting style into life. It featured everyday goods—wallpaper, wrapping paper, paper plates—designed by artists, notably Roy Lichtenstein. Although versions of On 1st were optimistically planned for other cities like Chicago, San Francisco, and Los Angeles, the venture was doomed by its timing. The expansive mood had vanished. New artists of the seventies turned inward, rejecting the commercial world, unable to sustain, in a particularly black moment, the previous generation's affection for popular culture and zest for postwar consumerism.

Rosa Esman continued Tanglewood Press Inc. (at 4 East 95th Street and later at 24 East 80th Street) through 1974, releasing *The Metropolitan Scene* screenprints on aluminum in 1968, second versions of *New York Ten* and *7 Objects in a Box* by new, young artists (1969), Christo's first edition of handpainted wall objects (1972), and a Helen Frankenthaler project (1974). Over the years she continued her involvement with multiples as a part of her activities at Rosa Esman Gallery. Today Rosa is a partner in Ubu, a gallery in the same space where the Bianchini Gallery presented the *American Supermarket* more than three decades ago.

Multiples, a trademark name registered by Marian Goodman, changed radically in the early 1970s when a Harvard Business School graduate named David Rawle bought 51% of the business (which also operated briefly in Los Angeles), creating a partnership that lasted until the beginning of 1974, at which time Goodman acquired sole owner-

ship of Multiples, which she operates today at 24 West 57th Street, in conjunction with Marian Goodman Gallery. Of her original partners, Barbara Kulicke is an artist living in Pennsylvania, Sonny Sloan and Robert Graham are no longer living, and Ursula Kalish is retired from the partnership. Ben Birillo, briefly a partner in Bianchini Gallery, lives in Fort Montgomery, New York, and enjoys vivid recall of the heady *American Supermarket* days when Dorothy Herzka met (and soon married) artist Roy Lichtenstein. Billy Klüver and his wife/partner Julie Martin live in New Jersey and continue to write, publish, and attend to the affairs of E.A.T., while Joan Kron and Audrey Sabol, the dynamic duo Billy encountered at the YM/YWHA in Philadelphia, have contributed significantly to this history (personally and through their papers in the Archives of American Art).

In the short view, Pop Art multiples had exactly the opposite effect as that predicted by their founders. Instead of democratically broadening the audience and denying big-ticket elitism, for the most part, the works went to members of a select "club" prepared to proffer—on upper-middle-class coffee tables—such things as resin baked potatoes and call them art. Before history could vindicate the vision of the membership, the sixties objects vanished down the rabbit hole of everyday use, untended by all but the most circumspect. Now they are indeed rare, and the absorption in their fabrication/flourishing/disappearance, plus the pleasure of rediscovery brings us here.

But perhaps Utopia was gained after all. This began as a story about artists and publishers linking their enthusiasms in a moment of inspired collaboration. It also turned out to be a story about the notion of "store" and the artists' celebration of everyday rituals set in the context of commerce. And, some three decades hence, multiples are common fare, not rare but destined for the widest shopping audiences who patronize both art stores and department stores. Recently, while surveying all the numbered, initialed, signed, stamped, limited, boxed goods at a local famous-name emporium, and after purchasing James Rosenquist's espresso cups complete with a Rosenquist-designed coffee can, I realized that, at long last, the *The Great American Pop Art Store* is not such a far-fetched concept after all.

Jasper Johns, *Bread*, 1969 (cat. no. 19) © 1997 Jasper Johns/Licensed by VAGA, New York, NY

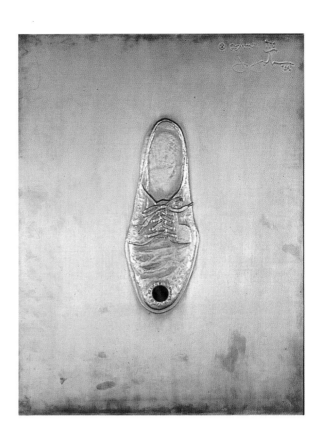

Jasper Johns, *High School Days*, 1969 (cat. no. 16) © 1997 Jasper Johns/Licensed by VAGA, New York, NY

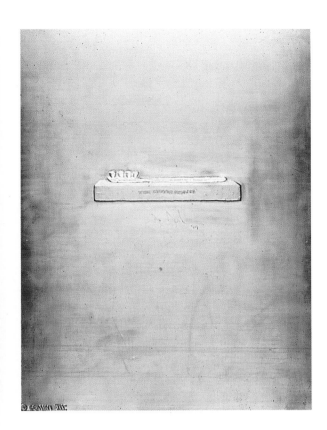

Jasper Johns, *The Critic Smiles*, 1969 (cat. no. 17) © 1997 Jasper Johns/Licensed by VAGA,
New York, NY

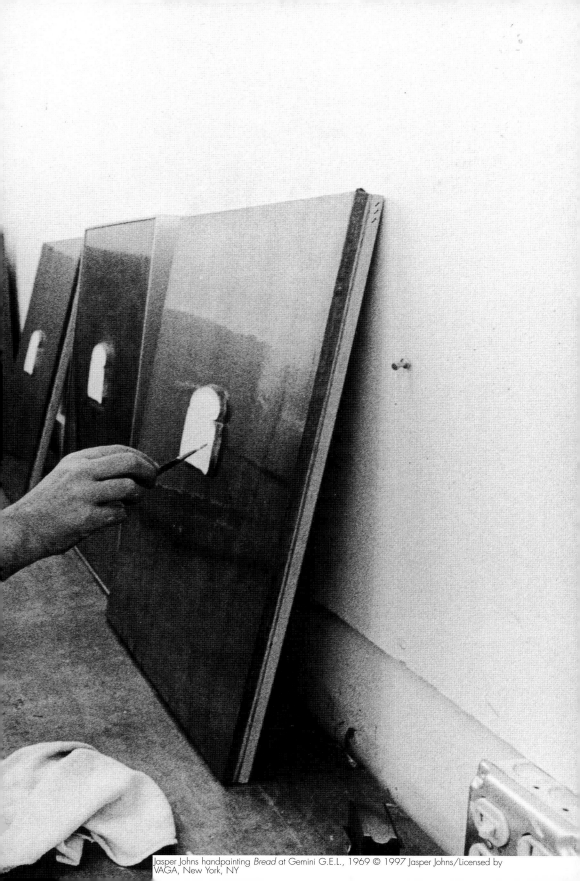

Jasper Johns handpainting *Bread* at Gemini G.E.L., 1969 © 1997 Jasper Johns/Licensed by VAGA, New York, NY

NOTES

1. Brian O'Doherty, "Pop Goes the New Art," *The New York Times*, 31 October 1962, p. 41.

2. Claes Oldenburg (1961), quoted in Germano Celant, Dieter Koepplin, and Mark Rosenthal, *Claes Oldenburg: An Anthology* (New York: Solomon R. Guggenheim Foundation, 1995), 96–97.

3. Calvin Tomkins, "Raggedy Andy," reprinted in Gerald Howard, ed. *The Sixties: The Art, Attitudes, Politics, and Media of our Most Explosive Decade* (New York: Marlowe & Company, 1995), 304-321.

4. The original stationery of the Betsy Ross Flag and Banner Company indicates that it was located at "41 East 11th Street, Algonquin 4-0140, Barbara Kulicke, Director." According to Joan Washburn, who was employed at the Graham Gallery at the time, the first fabricator—for nylon banners—was Arista Flag Corp; the second—soon engaged because of the ability to work in felt—was Abacrome. Both firms are still active in New York today.

5. Constance W. Glenn, *Time Dust: James Rosenquist, Complete Graphics 1962-1992* (New York: Rizzoli New York, 1993), 17.

6. Simon Frith and Howard Horne, *Art Into Pop* (London: Methuen and Co. Ltd, 1987), 33.

7. Ibid., 103.

8. *Horizon*, Vol. 6, no. 4, Autumn 1964, 26-31.

9. Although published estimates of the number of bags produced range from 200 to 300 each, Birillo states that he printed approximately 125 each; Ivan Karp concurs that the 200 to 300 figures are too high.

10. Grace Glueck, "Gallery Market Hawks Art On Rye," *The New York Times*, 8 October 1964, p. 51; also see Calvin Tomkins, "Art or not, it's food for thought," *Life*, 20 November 1964, 138-40, 143-44.

11. Warhol appeared in the *Life* article; Mrs. Scull in *The New York Times*.

12. The exhibition traveled to Galleria ilsegno in Rome, opening 12 March 1965 under Ben Birillo's auspices; from Rome it was sent on to Paris (date and location unknown), where Paul Bianchini—who spent a great deal of time in Paris—handled the details.

13. All comments and quotes attributed to Rosa Esman are derived from a recorded, unpublished interview with the author, Linda Albright-Tomb, and Dorothy Lichtenstein, 1 December 1995, in New York.

14. *New York Ten* was quickly followed by Esman's print portfolios *11 Pop Artists I, II, III*, 1966, published under her Original Editions imprint for Philip Morris.

15. E.A.T., Experiments in Art and Technology, was founded by Klüver and Rauschenberg in 1966.

16. *Claes Oldenburg: The Multiples Store. With Case Histories by Claes Oldenburg* (London: South Bank Centre, 1996), 14.

17. Letter from Barbara Kulicke to the author and Linda Albright-Tomb, 7 November 1995.

18. All comments and quotes attributed to Marian Goodman are derived from a recorded, unpublished interview with the author, Linda Albright-Tomb, and Dorothy Lichtenstein, 30 November 1995 in New York.

19. Grace Glueck, "Art Notes: M-M-Multiples," *The New York Times*, 31 October 1965, p. 29.

20. Peter Benchley, "The Story of Pop: What it is and how it came to be," *Newsweek*, 25 April 1966, 56.

21. J.P.F., *The Kansas City Star*, 27 March 1966, 4C.

22. "Retailing: Art over the Counter," *Time*, 7 May 1965, 94-96.

23. Ruth Berenson, "The Heritage of Pop." *National Review*, 19 September 1967, 1028, 1031-2.

24. The first all Pop Art exhibition outside of New York, *The New Painting of Common Objects*, September 25 - October 19, 1962, at the Pasadena Art Museum, was a survey of East Coast/West Coast Pop.

25. Correspondence, "The Museum of Merchandise," the Joan Kron and Audrey Sabol Papers, Archives of American Art, Smithsonian Institution.

26. Constance W. Glenn, "American Pop Art: A Prologue," in *Pop Art*, ed. Marco Livingstone (London: Royal Academy of Arts and Weidenfeld and Nicolson, 1991), 28.

27. Irene Lacher, "In the Foyer of the Apocalypse," *Los Angeles Times*, 26 September 1996, sec. E, p. 1, 8.

28. James R. Carroll, "Nation carries scars of 1968," *Press-Telegram* (Long Beach, California), 25 August 1996, p. A4.

29. Tomkins, "Raggedy Andy," in *The Sixties*, 320-21.

30. Riva Castelman, *Technics and Creativity: Gemini G.E.L.* (New York: The Museum of Modern Art, 1971), 19.

31. Peter Schjeldahl, "Three for the Mini-Show," *The New York Times*, 19 January 1970, p. D17.

32. Carter Ratcliff, *SMS: A Collection of Original Multiples Published in 1968 by The Letter Edged in Black Press* (New York: Reinhold-Brown Gallery, c. 1981), unpaginated.

REMEMBERING THE AMERICAN SUPERMARKET

DOROTHY HERZKA LICHTENSTEIN

We were really out of the mainstream in 1962. The Bianchini Gallery, where I worked, was showing a lot of European art—primarily master drawings. But, right around the corner at 4 East 77th Street was the Castelli Gallery, which was an important part of the Saturday gallery-going scene.

It wasn't too long before Ivan Karp [of Castelli] sent the artist Ben Birillo by to see Paul [Bianchini]. Ben knew the art world and knew what was going on. He really was a tremendous catalyst. With his help the gallery actually started looking for contemporary artists to show but, as it turned out, many were already with Castelli, or Janis, or Green, or Kornblee. With Ben, we began to try to think of ways we could show—in special exhibitions—the work of artists the gallery could not represent. An influential artist—whom we did take on—was Bob Watts. Bob was working with food, neon signs, and common store items and, of course, he knew Ben. Ivan, too, was an enormous influence, but it was Ben who conceived the American Supermarket show in our conversations in the gallery. We realized there were all kinds of plastic foods and there were also objects—art objects—that looked like food, plus we were aware of Jasper's [Johns] ale cans. In fact, we began to think of the art that was happening at the time in the context of the "great American supermarket." There was always the intention that the show would be part art and part non-art. We loved the idea of mixing real food—the frozen blintzes we ordered as opening night gifts—fake food, and art all together. We didn't have any perishable food in the show, although Bob Watts had made a cake he iced as the Mona Lisa, and at the opening guests were fighting over the smile.

All sorts of people came, and the event of the evening was the Sculls' removal of the ale cans they had lent. We had, of course, borrowed many things to intermingle with the objects that were for sale. The grocery bins Ben had made contained Bob Watts' fruits and vegetables, which were for sale, as where the meats by the woman he discovered making commercial display food. In fact, the artists in the Supermarket show had started going to certain types of businesses to get their work fabricated, just as the Minimalists were seeking out industrial fabricators. Over the counters or bins we put up shelves, where we stacked cans of Campbell's Soup—real soup cans that Andy had initialed. Once the show had been planned, the shopping bag idea took the place of a traditional poster. We bought plain white bags, Andy [Warhol] and Roy [Lichtenstein] lent the images, and Ben silkscreened them. In fact, I first met Roy when he came in the gallery to sign them. I loved the idea that they were real shopping bags that people could take home or use for their purchases. They were a novelty and many collectors just used them until they fell apart. We were aware of the questions raised: "What is the difference between these supermarket objects and art? What is the difference between an ordinary Campbell's Soup can and one signed by Andy?" These distinctions, in general, were questions that people were thinking about at the time. Issues of ambiguity were an important aspect of Pop Art. I am sure, however, that people did not think the Supermarket objects would ever become rare or expensive. The American Supermarket was, in its own way, a Happening or an environment, not that distant from the environments collectors like the Sculls would eventually create in their own homes, but the idea, the germ of American multiples, was contained within it.

While the Beat movement had been very cynical about the American landscape, in the sixties we celebrated popular culture. I think the most crucial idea of the time was that rich, poor, black, white, male, female, we were all one. It was an innocent moment and—in the case of the Supermarket multiples—I think there was general delight in the fact—not that they weren't serious—that they were not precious.

Excerpted by Constance W. Glenn from an interview, 30 November 1995

WELCOME TO THE HYPERREAL

KAREN L. KLEINFELDER

A day will come when, by means of similitude relayed indefinitely along the length of a series, the image itself, along with the name it bears, will lose its identity. Campbell, Campbell, Campbell, Campbell.[1]

—Michel Foucault

In a way, that day has not come, because the brand name Campbell still has not lost its identity for us in a postmodern age. In fact, after thirty-some years it has, if anything, taken on added identity by means of association: Warhol, Warhol, Warhol, Warhol. Now, even more than in the sixties, when Andy first started initialing those red-and-white labels, Campbell's soup is inextricably linked with Warhol's hype. Mutation or not, the object-sign has taken on a multiple value or excess signification that has little to do with soup or any form of canned "goods." Whether Warhol intended it or not, the Campbell's soup can label has, in effect, become Andy's personal logo, a kind of pre-fab designer label that signifies Pop Art first and chicken noodle a distant second.

Such is the fate of objects in the current post-Pop age that sociologist Jean Baudrillard has dubbed "the Hyperreal."[2] The use-value of the commodity object has been eclipsed by its sign-value, its aura, its hype.[3] We crave the designer label more than the product. In such a scenario, where the real has literally become a scenario, production is no longer the center of the exchange system; consumption is,[4] and what rules over the subject is the seduction of the object.[5] Disneyland, phone sex, and Nintendo 64 offer escapes from the "real," but Baudrillard, with a kind of sci-fi warning tone, points out something we may have overlooked: "Disneyland is presented as imaginary in order to make us believe that the rest is real, when in fact all of Los Angeles and the America surrounding it are no longer real, but of the order of the Hyperreal and of simulation. It is no longer a question of a false representation of reality (ideology), but of concealing the fact that the real is no longer real. . . . "[6] Image, spectacle, and simulation become the stuff not only of which dreams are made, but of which reality is formed,[7] as ever-proliferating models, codes, and networks take more and more control over thought and behavior. "I love Los Angeles. I love Hollywood. They're beautiful. Everybody's plastic, but I love plastic. I want to be plastic," Warhol confessed.[8] Such

are the ecstasies of our new postmodern condition in which computers, media, and technology define an experience that takes us outside or beyond ourselves. But it is an ecstasy that is also accompanied by inertia as the system implodes and the subject's excitement turns to exhaustion when the spectacle proves overwhelming and stagnation sets in.[9] Warhol summed it up best in his motto for a postmodern age: "bored, but hyper."

The multiples of the sixties anticipated the logic of simulation and the Hyperreal before Baudrillard ever came on the scene. Serial without being narrative, the multiples challenged the sacred aura of the "original" and the entire system of referentiality. In their assembly-line succession, they tracked to neither a definitive point of origin nor one of exit, but only to a closed-loop sign-system in which there was no traceable referent, no way to ground the proliferating circulation or fix and stabilize meaning. The system of objects no longer represented some external reality, but instead spiraled off on its own, a succession of detached signifers becoming their own signifieds. "In this vertigo of serial signs— shadowless, impossible to sublimate, immanent in their repetition—who can say where the reality of what they simulate resides?"[10] Baudrillard's question follows a direct reference to Warhol, and we can see, thus, how theories of the Hyperreal were spun in part to explain such "novelties" as the multiples, which deviated radically from traditional modes of artistic production. From today's postmodern vantage point, the multiples no longer can be cursorily dismissed as some marginal pastime on the sidelines of Pop Art; on the contrary, the sixties multiples seem all-too-prophetic, marking a radical break from the past and pointing to the Hyperreal future. The modernist search for value and meaning takes on a nostalgic tone as the multiples shift directions on us, away from any illusory point of origin, hidden depths, mystical essence, or fictive authenticity. What we are left with are models, codes, and simulacra. "All my films are artificial," Andy admits. "But then everything is sort of artificial. I don't know where the artificial stops and the real starts. The artificial fascinates me, the bright and shiny. . . . "[11] Welcome to the Hyperreal.

In this brave, new world of media spectacle and high-tech fantasies more real than the real, what has happened to the multiples concept of the sixties? Quite in keeping with the logic of simulation and the Hyperreal, multiples have grown and multiplied in the eighties and nineties. For your consumption, we now have Jenny Holzer T-shirts, pencils and golf balls with "truisms" stamped on them and, my personal favorite, a Barbara Kruger shopping bag to hold it all, with her highly imitated (simulated?) "signature" red-and-black logo design sending

us a message from the Hyperreal: "I shop therefore I am." But wait, there's more. (There's always more in the excess economy of simulations spiraling beyond control.) From Katharina Fritsch's Day-Glo plaster *Madonnas*,[12] available in an unlimited number of multiples, to Jeff Koons's polychromed porcelain *Pink Panther*,[13] the banal hyped up in a more rarified edition of three, the multiples keep on coming until finally we end up in a room full of Mike Bidlo's simulations of Brancusi's *Mlle. Pogany*,[14] a modernist sculpture that once, long ago it now seems, epitomized the search for an essence.

 In the ever-lengthening chain of multiples, however, there still seems room for multiple takes on the theme, even room for social opposition. Baudrillard himself would be highly skeptical of such a claim since he sees the age of simulation as "the end of the social." In an imploding Hyperreal, the continual barrage of media messages turns the masses into a dazed and numb "silent majority."[15] The potential for opposition disappears from the scene and, along with it, the revolt that had characterized the modernist avant-garde. Art, like everything else, gets caught up in the play of simulations.[16] But multiple in character as they are, the multiples do not always play according to the rules of Baudrillard's game. In 1991–92 Peggy Diggs printed subversive messages about domestic violence on milk cartons.[17] The edition of 1,500,000 half-gallon containers posed such questions as, "When you argue at home, does it always get out of hand?" along with an 800 hotline number to call for help. The milk-carton multiples, thus, brought opposition to domestic violence directly into the home. Such portability is one of the advantages of multiples for artists attempting to work in a social sphere that extends beyond the institutional context of museums and galleries. Holzer's pencils inscribed with "truisms"—"Abuse of power comes as no surprise" or "Raise boys and girls the same way"—could turn up virtually anywhere, or get passed around from one person to the next in a kind of hand-to-hand exchange that defies the collapse of the social. Recently an eclectic group of artists collaborated on an *Act Up Art Box*,[18] a multiple consisting of a wooden box with cover design by Nancy Spero, and containing various objects by Ross Bleckner, Louise Bourgeois, Mike Kelley, Simon Leung, Lorna Simpson, and Kiki Smith. The project was a fundraiser for Act Up, a group committed to helping end the AIDS crisis. The "sign-value" of the objects placed in the box was not the typical hype. They were conceived as *memento mori*, or reminders to us all of the mortality that awaits, even here, or perhaps especially here, in the Hyperreal.

 Is death the only way out of the Hyperreal? Or is that too singular a line of thought for an age of multiples, simulations, and hypertexts that suggests an end to simpleminded notions of linear progression? Multiples track us in multiple directions at once, problematizing the idea of a mythical point of origin or any longed-for closure along the way, and resisting easy reduction to one classification or another. Packaged parodies of consumer lust or artists cashing in with their own designer logos, multiples manage to circulate in the marketplace as well as in art venues (is there any *real* difference?), and new spaces for varied forms of artist-and-audience exchange—from affordable T-shirts to interactive CD-ROMS—have opened up in the process. Multiples may not alter the rules of the game in a Hyperreal where simulation is the code and mass media tactics are the norm, but they do suggest multiple ways to play the game. Take a lesson from Andy:

> I'd prefer to remain a mystery. I never give my background, and anyway,
> I make it all up different every time I'm asked.[19]

NOTES

1. Michel Foucault, *This is Not a Pipe*, trans. and ed. J. Harkness (Berkeley: University of California Press, 1983), 54.

2. See Jean Baudrillard, *L'Echange symbolique et la mort* (Paris: Gallimard, 1976), and "Symbolic Exchange and Death," trans. J. Mourrain, in *Jean Baudrillard: Selected Writings*, ed. M. Poster (Stanford: Stanford University Press, 1988), 119-148. Also, "Simulacra and Simulations," trans. P. Foss, P. Patton, and P. Beitchman, in *Baudrillard: Selected Writings* (original publication, 1981), 166-184. For a good introduction to Baudrillard's theory, see Douglas Kellner, "Introduction: Jean Baudrillard in the Fin-de-Millennium," in *Baudrillard: A Critical Reader*, ed. D. Kellner (Oxford: Blackwell, 1994), 1-23.

3. See Baudrillard, *Le Système des objets* (Paris: Gallimard, 1968), and "The System of Objects," trans. J. Mourrain, in *Baudrillard: Selected Writings*, 10-28, especially 22.

4. See Baudrillard, *La Société de consommation* (Paris: Gallimard, 1970), and "Consumer Society," trans. J. Mourrain, in *Baudrillard: Selected Writings*, 29-56.

5. See Baudrillard, *De la séduction* (Paris: Editions Galilée, 1979), and "Seduction," trans. J. Mourrain, in *Baudrillard: Selected Writings*, 149-165.

6. Baudrillard, "Simulacra and Simulations," in *Baudrillard: Selected Writings*, 172.

7. " . . . today, *reality itself is hyperrealistic*" (Baudrillard's italics); see Baudrillard, "Symbolic Exchange and Death," in *Baudrillard: Selected Writings*, 146.

8. Andy Warhol (1968), in *Andy Warhol*, eds. A. Warhol, K. König, P. Hultén, and O. Granath (Boston: Boston Book and Art Publisher, 1970; catalogue for exhibition at the Moderna Museet, Stockholm): unpaginated.

9. See Baudrillard, *Les strategies fatales* (Paris: Bernard Grasset, 1983), and "Fatal Strategies," trans. J. Mourrain, in *Baudrillard: Selected Writings*, 185-206.

10. Baudrillard, "Symbolic Exchange and Death," in *Baudrillard: Selected Writingss*, 147.

11. Warhol (1968), in *Andy Warhol*.

12. Katharina Fritsch, *Madonna* (1982–); an unlimited multiple in plaster with pigment. Reproduced in Deborah Wye, *Thinking Print: Books to Billboards, 1980–95* (New York: The Museum of Modern Art, 1996), plate 88, p. 81.

13. Jeff Koons, *Pink Panther* (1988), porcelain, edition of three. Reproduced in *Jeff Koons*, ed. A. Muthesius (Cologne: Benedikt Taschen, 1992), 114-115.

14. Mike Bidlo, installation of refabricated versions of Brancusi's *Mlle. Pogany*. Reproduced in Peter Frank and Michael McKenzie, *New, Used and Improved* (New York: Abbeville Press, 1987), 96.

15. See Baudrillard, *A l'ombre des majorités silencieuses, ou La fin du social* (Fontenay-Sous-Bois: Cahiers d'Utopie, 1978) and *In the Shadow of the Silent Majorities* (New York: Semiotext(e), 1983).

16. See Baudrillard, "Symbolic Exchange and Death," 147.

17. See Peggy Diggs, *Domestic Violence Milkcarton Project* (1991–92); multiple in an edition of 1,500,000. Reproduced in Wye, *Thinking Print*, plate 86, p. 80.

18. Various artists, *Act Up Art Box* (1993-94, multiple, edition of 95), reproduced in Wye, *Thinking Print*, plate 85, p. 80.

19. Warhol (1968), in *Andy Warhol*.

ANNOTATED BIBLIOGRAPHY

by Linda Albright-Tomb

JOURNAL AND NEWSPAPER ARTICLES

Amaya, Mario. "Collectors: Mr. and Mrs. Jack W. Glenn." *Art in America* 58 (March 1970): 86-93.
In-depth article about Mr. and Mrs. Glenn, who were among the earliest collectors of Pop Art. Photographs of their home including Oldenburg's *Wedding Souvenir*, Watts' *Bacon, Lettuce and Tomato Sandwich*, and Wesselmann's *Seascape*.

"Art: At Home with Henry." *Time*, 21 February 1964, 68-71.
Portrait of Robert and Ethel Scull, perhaps the most renowned Pop Art collectors. Various color *in situ* photographs of their home.

"Art in Duplicate." *Interior Design* 43, no. 1 (January 1972): 28.
One-page profile of Multiples Inc.; mentions Lichtenstein's *Modern Head Brooch*.

Ashton, Dore. "Correspondents: Letter from New York." *Canadian Art* 20, no. 4 (July/August 1963): 244-45.
Overview of the 1962-63 New York newspaper strike and the banners it spawned.

Benchley, Peter. "The Story of Pop: What it is and how it came to be." *Newsweek*, 25 April 1966, 56-61.
Discusses the pervasive presence of the Pop style, which invaded the worlds of fashion, television, advertising, art, and more. Discusses Dada and common areas of subject matter. Provides good overview of the flavor of the era.

Berenson, Ruth. "The Heritage of Pop." *National Review*, 19 September 1967, 1028, 1031-2.
A review of the years 1962–67 in the artworld, and the "rise" and "fall" of Pop Art. Sees Pop Art as a fad, much like the Hard Edge, Op, Kinetic, psychedelic and Minimal trends which she suggests will fade away with time.

Bird, Peter. "Multikonst: A Swedish project in the distribution of prints and multiple art-objects." *Studio International* 174, no. 895 (December 1967): 294.
Describes a Swedish experiment in which 100 venues opened with the same show (i.e., the same objects at each venue). Raises the issue of bringing high art down to the masses. Seen as a successful experiment.

Bordier, Roger. "Who is Multiplying What?" *Cimaise* no. 110-111 (January-April 1973): 50-5.
In French and English. Philosophical discussion of the concept of the unique work of art. Covers many arts: painting, photography, cinema, literature.

Constable, Rosalind. "The more mundane, the better it suits pop." *Life*, 26 February 1965, 66A.
Brief, humorous look at manufacturers' involvement in the production of multiples.

Cutler, C. "Multiples in Paris." *Art in America* 56, no. 6 (November 1968): 92-4.
Notes that the Pop Art consumer lifestyle invaded Paris in 1965. Discusses Denise René and many other European galleries involved in the movement.

Darzacq, Dominique. "Expressions Plastiques: De l'Art à Revendre." *Connaissance des Arts* no. 213 (November 1969): 100-5.
In French. Little text; primarily photographs of European multiples.

Deighton, Elizabeth. "Multiples and Marketing." *Studio International* 177, no. 910 (April 1969): 194.
Review of an exhibition at the Ikon Gallery, Birmingham, England, which was the result of a competition. Expresses the need for a store for art multiples. Discusses positive effect of selling these objects.

De Sanna, J. "Multiples, Do They Exist?" *Domus* no. 528 (11 November 1973): 1-4.
In Italian, summary in English. States that the modern idea of multiples stems from Moholy-Nagy's 1920s concepts. Author contends multiples must not be produced by hand or by traditional techniques, and that they must be kinetic. Suggests that due to their nature, and the requirement made by certain "specialists" that the price of the objects should be twice that of the production cost (irrespective of a particular artist's fame), the multiple is an industrial product. Reproduces Oldenburg's *Profile Airflow* and an advertisement for Lichtenstein's *Dishes*.

De Vuono, Frances. "Reviews: Claes Oldenburg: Prints and Multiples." *ARTnews* 89, no. 9 (November 1990): 162.
Review of the Oldenburg exhibit at Susan Sheehan Gallery, New York. Covers 28 years and 36 works. Includes *Tea Bag*, 1966.

Eco, Umberto. "Eugenio Carmi: The Value of the Temporary." *Art International* 13, no. 5 (May 1969): 21-6.
Refers to Benjamin's "The Work of Art in the Age of Mechanical Reproduction," and provides philosophical discussion on original works of art and multiples. Finally, discusses Carmi's work.

"Far-out Refrigerators." *Life*, 26 February 1965, 55-6.
Attests to the pervasive Pop Art lifestyle. Even refrigerators sport Pop Art fashion.

"Fashion: Styles too are pushed further out by Pop." *Life*, 26 February 1965, 59-60.
Entertaining look at Pop Art fashion.

Friedman, Ken. "On Fluxus." *Flash Art* no. 84-85 (October/November 1978): 30-3.
An interesting and thorough overview of the Fluxus movement (of which the author was a part). Notes that the Fluxus group was involved in producing multiples during its third incarnation.

Fusco, A. "A Reproposal of the 'Multiple.'" *Op. Cit.* no. 36 (May 1976): 43-53.
In Italian, summary in English. Examines multiples as an Italian art form. Explores their history in Italy, and the social ideology surrounding them. Anti-elite art. Also discusses the creation of the unlimited multiple, which defies market forces.

Glueck, Grace. "Gallery Market Hawks Art on Rye," *The New York Times*, 8 October 1964, p. 51.
Review of the *American Supermarket*.

Glueck, Grace. "Art Notes: M-M-Multiples." *The New York Times*, 31 October 1965, p. 29.
Announces the opening and describes the new Multiples gallery and offers insights and quotes regarding the democratic goals of its founders.

Glueck, Grace. "If It's Art You Want, Try Your Supermarket." *The New York Times*, 6 August 1967, sec. D. p.19.

Goldman, Judith. "The Case of the Baked Potatoes." *The Print Collector's Newsletter* 3, no. 2 (May/June 1972): 34-7.
Discussion of the forgery of Oldenburg's *Baked Potato*.

Gray, Francine du Plessix. "The House that Pop Art Built." *House & Garden* 127 (May 1965): 1958-63.
Intimate look into the environment and lifestyle of Pop Art collector Leon Kraushar. Various color reproductions of the interior of his home.

"Great Art Buys You Can Afford." *Mademoiselle* 68 (December 1968): 118-21.
Brief, photographic overview of works of art which sell for $23 to $250 in department stores and art galleries. Reproduction of Lichtenstein's *Dishes*.

Greenfield, Josh. "Sort of the Svengali of Pop." *The New York Times Magazine*, 8 May 1966, p. 34-5.
Portrait of Leo Castelli, a "gallant pacesetter." Provides an in-depth look at the gallery, its shows, prices, artists. Comments on his strong but quirky personality.

Grenauer, Emily. "Can This be Art?" *Ladies Home Journal* 81 (March 1964): 151-55.
Notes the prevalence of Pop Art in New York; suggests that it still has not infiltrated the Midwest. Attempts to explain Pop Art vis à vis Abstract Expressionism.

Gruen, John. "Art's New Originals." *American Home* 73 (April 1970): 50-54.
Excellent article. Explains the multiples phenomenon in a concise manner. Reproduces Lichtenstein's *Modern Head Brooch* and Rivers' *Cigar Box*.

Keller, Dominik. "Multiples." *Du* 420, no. 36 (February 1976): 52-9.
In German, one-page summary in English. Credits Duchamp, Denise René, and Spoerri as originators of multiples. Claims the root of multiples is in the casting process of sculpture (wax models, etc.). Discusses photography as multiple art as well. European focus. Reproduces Warhol's *Campbell Soup Can* and Watts' *Hot Dog*.

Kendall, Elaine. "Art Without Artists." *The Reporter*, 23 May 1963, 45-6.
Provides a good historical background for Pop Art, dating it to Dada and Duchamp. Claims Pop Art is in dire need of Pop Art critics.

Kihss, Peter. "Papers Greeted in a Holiday Air." *The New York Times*, 2 April 1963, p. 41.
Reports on the first day following the end of the 114-day newspaper strike which precipitated the founding of the Betsy Ross Flag and Banner Company.

Kohn, Linda. "In My Opinion: Teens should open their eyes to pop, op, top, and hop." *Seventeen* 25 (April 1966): 272.
A refreshing viewpoint of the Pop Art phenomenon, offered by a 16-year-old.

Kozloff, Max. "Three-Dimensional Prints and the Retreat from Originality." *Artforum* 4, no. 4 (December 1965): 25-7.
Discusses the history of the multiple, beginning with Spoerri and Édition MAT. Mentions Marian Goodman and the Betsy Ross Flag and Banner Company. Explores the artist/craftsman issue, original works of art, multiples. Discusses contributions by Duchamp, Warhol, Dine, and Rivers.

Kramer, Hilton. "Episodes from the Sixties." *Art in America* 58 (January 1970): 56-61.
Excellent review of the styles and climate that prevailed in the 1960s' American artworld.

Kramer, Jane. "Profiles: Man Who is Happening Now." *The New Yorker*, 26 November 1966, 64-6.
In-depth, entertaining profile of Robert Scull. Offers an intimate look at his life and commitment to the contemporary artworld.

Krauss, Rosalind E. "The Originality of the Avante-Garde: A Postmodernist Repetition." *October* 18 (Fall 1981): 47-66.
Discusses casts and multiples in Rodin's oeuvre and the legitimacy of a cast made of the *Gates of Hell* in 1978. Examines contradictions in the notion of originality in avant-garde art. Argues that the copy is the "repressed underlying condition of the original." Uses the works of Austen, Johnson, and Monet to prove this point. Discusses the silkscreens of Rauschenberg.

Kultermann, Udo. "On Multiples." *Du* 36, no. 420 (February 1976): 52-65.
In German, abstract in English. Proposes that the multiple is an industrial, democratic object first produced by Spoerri, Albers, Duchamp, Man Ray, Vasarely, and Moholy-Nagy. Argues that the multiple does not lose its character as art merely because it is produced in quantity. The relationship of the artist to the machine goes to the heart of the problems of art, society, and their worth.

"Reproduction Originals for the Masses: Aspects of an Industrial Art." *Alte und Moderne Kunst* 22, no. 152 (1977): 30-4.
In German, abstract in English. Questions whether machinery can produce a work of art. Looks at the growth of the graphic arts from their beginnings and the effect of mass production on the quality of art work. Discusses Duchamp's attitude toward the original work of art, and the work of Tatlin, Moholy-Nagy, Vasarely, and Fautrier. Ends with a look at the market for mass-produced art.

Le Bot, Marc. "Series and Seriality." *Revue d'Esthetique* no. 3-4 (1974): 33-49.
In French, abstract in English. Proposes that multiples existed in Medieval, Renaissance, and Classical times, but for "transcendental" purposes. Now they are a postindustrial phenomenon, and not necessarily a favorable one. Promotes mass production, capitalism, and the "segregation of the artist from society."

Loring, John. "American Portrait." *Arts Magazine* 50, no. 3 (November 1975): 58-9.
Discusses Trans World Art's contribution to the American Bicentennial, a three-part portfolio of original graphics, multiples,

and American writings from the past and present. Among the 33 artists are Rivers, Indiana, and Rosenquist.

Marabottini, Alessandro. "Forgeries and Repudiations in Contemporary Art." *Problemi di Ulisse* 12, no. 76 (1973): 156-69.
In Italian, abstract in English. Suggests technology has made art a mass-produced medium, subject to the laws of the marketplace. Multiples are not forgeries if the artist has agreed to their production.

"Market: Heralding Bold Banners." *Interiors* 130 (September 1970): 78.
Reports Multiples Inc.'s introduction of a new series of vinyl and felt banners by Wesselmann and Trova, among others. Includes reproductions of banners by Lichtenstein, Indiana, and Ortman.

Mattick, Paul. "Mechanical Reproduction in the Age of Art." *Arts Magazine* 65, no. 1 (September 1990): 62-9.
Author refers to Benjamin's famous essay and explores the effect of the invention of photography on art and the difference between copies and multiples (a point which he feels Benjamin neglected to consider). Believes Benjamin's essay has led to misunderstandings about the nature of reproduction. Addresses the notion of the aura of a work of art. Concludes with a brief discussion of Benjamin's analysis in light of contemporary art. Extensive bibliography and footnotes.

"Multiple Art in Three Dimensions." *Architectural Digest* 33, no. 2 (September/October 1976): 136-41.
Suggests multiples are a way of fusing art and life, and that new technologies have much to do with their florescence. Mentions Oldenburg, Wesselmann, Segal, and Lichtenstein. Claims Duchamp's Readymades signal the beginning of multiples. Notes the difference between American and European multiples.

"Multiples." *Art & Artists* no. 5 (January 1971): 4.
Letter to the editor written by John Pearce from Switzerland regarding multiples. Comments on the historical context of the multiples movement.

"Multiples Supplement." *Art & Artists* no. 4 (June 1969): 10, 29-45, 48-5, 52, 54, 56, 64-5.
Offers a good, general history of multiples. Explores multiples of Moholy-Nagy, Vasarely; discusses Wedgwood and Portland Vase; offers overview of competitions and workshops; gives various definitions of multiples in New York, England, Wales; discusses issues of quality and quantity; overview of galleries in U.S., Holland, Italy, Germany; various artists, including Rivers and Oldenburg.

"Multiples supplement." *Studio International* 183, no. 936 (September 1971): 92-8, 100, 102, 104.
Historical analysis (Roman figurines, Renaissance bronzes, etc.) and philosophical discussion; multiples in various countries, including the U.S.; multiples directory.

"Multiples supplement." *Studio International* 184, no. 947 (September 1972): 94-108.
Discusses Beuys' involvement; provides a philosophical analysis; history, Duchamp, and role of museums; democratization of art; various cities involved in movement; Rosenquist and Oldenburg.

"Multiples 2." *Art & Artists* no. 4 (November 1970): 57-60, 62, 64, 66, 70.
Discusses Whitechapel show (*Three —› ∞: New Multiple Art*) which claimed to be the first international multiples exhibit and included artists from the U.S., South America, Japan; notes multiples various production by artists in a variety of countries; provides a multiples directory.

Nemy, Enid. "2 Housewives Form 'Almost a Cartel.'" *The New York Times*, 17 August 1965, sec. L, p. 25.
Joan Kron and Audrey Sabol discuss multiples published including Robert Indiana's *EAT* brooch.

"New York Galleries: Multiples, Inc." *Arts Magazine* 45, no. 6 (April 1971): 67.
Review of the gallery that began in 1965 and produced jewelry, banners, objects, and graphics. Reproduction of Oldenburg's *Miniature Soft Drum Set*.

"N.Y. Protects Sculpture Buyers." *Art in America* no. 5 (May 1991): 192.
New consumer protection law for cast sculpture imposes extensive

requirements on sellers and makers of sculptural multiples.

"Oldenburg on Multiples." *Arts Magazine* 48 (May 1974): 42-5.
In-depth interview with Oldenburg; provides his thoughts, reasons for making multiples.

"Open to Re-definition." *Arts Magazine* 48, no.2 (November 1973): 42-3.
Explores the definition of an original print. Claims Warhol's wallpaper belongs to the print category. Primarily discusses Flavin, Oppenheim, and Christo.

Overy, Paul and Rory McEwen, et al. "A discussion on multiples." *Studio International* 180, no. 925 (September 1970): 103-6, 111-12.
A good roundtable discussion focusing on the definition of a multiple; provides directory of dealers and highlights new and recent multiples.

Palazzoli, Daniela. "Italian Commentary: Prints, Multiples, and 'Object Books'." *Studio International* 175, no. 901 (June 1968): 323-5.
Compares prints, multiples, and object books.

Piene, Nan R. "Art Under $500." *Art in America* 58, no. 3 (May 1970): 94-101.
Explains the proliferation of inexpensive art objects as a result of lifestyles which are "decorative" and "casual." Reproduces Ruscha's *Every Building on the Sunset Strip*, among others.

Plumb, Barbara. "Banners With Original Art Cut Cost of Decorating Walls: Felt Hangings Utilized in Place of Paintings." *The New York Times* 22 May 1964, p. 38.
Review of the banners produced by the Betsy Ross Flag and Banner Company. Lists prices of some; reproduces those by Marisol, Indiana, Anuszkiewicz, Youngerman, Wesselmann, and Ortman.

"Pop Art: Cult of the Commonplace." *Time*, 3 May 1963, 69-72.
Offers the original 1956 Alloway definition of Pop Art, and a brief survey of the American artists involved, including Dine, Lichtenstein, Johns, Oldenburg, Rivers, and Warhol.

"Print and Multiple Supplement." *Art & Artists* no. 7 (April 1972): 50-5.
One page summary/overview; multiples directory.

Reif, Rita. "Pow! Pow! Pow! Banners! They Unfurl as Art in the Home." *The New York Times*, 24 February 1966, p. 33.
A brief history of the Betsy Ross Flag and Banner Company; reproduces *Pistol* by Lichtenstein and the unpublished pie banner prototype by Thiebaud.

"Retailing: Art over the Counter." *Time*, 7 May 1965, 94, 96.
Brief look at department stores that have begun to open art sections in order to sell art by well-known artists. Sears, E.J. Korvette Inc., and The May Co. are among them.

Rose, Barbara. "The Airflow Multiple of Claes Oldenburg." *Studio International* 179, no. 923 (June 1970): 254-5.
Detailed analysis of Oldenburg's *Profile Airflow*.

Rosenstein, Harris. "Climbing Mt. Oldenburg." *ARTnews* 64, no. 10 (February 1966): 21-5, 56-9.
The cover of this issue is an Oldenburg multiple: a blue 1936 Chrysler box, ready to be cut and assembled. Article provides good coverage of Oldenburg's work prior to 1966 exhibition at Janis Gallery. Reproductions of *Soft Chrysler Airflow 1 & 2*, 1965, plus sketch of the artist working on it, and a discussion of the series. This predates the multiple version, yet gives good background. Discusses involvement in Happenings.

Schjeldahl, Peter. "Three for the Mini-Show." *The New York Times*, 19 July 1970, sec. D, p.17.
The author explores the 1970s multiples climate.

Schwartz, Therese. "The Politicalization of the Avant-Garde, II." *Art in America* 60, no. 2 (March-April 1972): 70-9.
Second article in continuing series on art and politics; retraces course of artists' activism. Recounts the effect political events had on Oldenburg, Lichtenstein, and Rosenquist in 1968. Mentions Feigen's *Richard J. Daley* exhibition.

"Selling Like Hot Cakes." *Industrial Design* 17, no. 7 (September 1970): 60-1.

Recounts the successful selling of multiples. MOMA commissioned 70,000 items to be sold in the museum shop. The company Artmongers and Manufactory Inc. carried out the request.

Sheppard, Eugenia. "The Two-Dollar Egg." *The New York Times*, 8 October 1968, p. 51.
Review of the *American Supermarket*.

"Sort of Commercial for Objects." *The Print Collector's Newsletter* 2, no. 6 (January/February 1972): 117-20.
An interview in which Oldenburg discusses his interest in print and object making. Examines the production of the *Baked Potato* multiple.

Spencer, Charles. "The Life and Death of the Multiple." *Studio International* 186, no. 958 (September 1973): 93-4.
Gives history of multiples; offers multiples directory.

Stuart-Penrose, Barrie. "Saleroom: What Constitutes an Original Work of Art?" *Art & Artists* no. 4 (July 1969): 12.
Discusses tax issues: editions of over 75 (prints) are taxable; editions of over 10 (sculpture) are taxable. A call to revise the law.

Sverbeyeff, Elizabeth. "Life with Pop." *The New York Times Magazine*, 2 May 1965, p. 98-9.
A look at two individuals who live with Pop Art—Leo Castelli, and an "amateur" who remains unnamed. Excellent reproductions, including chrome-plated wax pears by Watts and Warhol *Brillo Boxes*.

"The Era of the Multiple." *Galerie-Jardin des Arts* no. 147 (May 1975): 75-106.
In French, abstract in English. A 30-page examination of the multiple. Includes the opinions of various critics, artists and historians, among them Vasarely, Arman, Agam, and Takis. Provides interesting statistics.

"The New Visual Arts Multiples Law: Its Impact on Artists, Dealers, and Collectors." *Print Review* 16 (1983): 65-78.
Provides excerpts of a 1982 discussion on the New York visual arts multiples law.

Thomas, Robert. "Graphics: Segal, Sedgley and Gordy." *Art & Artists* no. 4 (February 1970): 28.
Discusses Alecto Gallery (New York and London) and its recent involvement in multiple objects by the above artists.

Tomkins, Calvin. "Profiles: Not Seen and/or Less Seen." *The New Yorker*, 6 February 1965, 37-40.
Excellent overview of the contemporary art scene, especially the birth of Pop Art, Happenings, Op Art, Kinetic art, film, and environments. Compares art of the day to the ideas of Marcel Duchamp. Interviews Duchamp, who at this time is called an "idol of a growing cult."

"You Go Past the 'O' and Under the 'N'. . ." *The New York Times*, 15 November 1968, p. 51.
Review of Bert Stern's store, On First, created to sell everyday objects designed by artists. Two illustrations: manager of the store with Lichtenstein *Wrapping Paper*; Stern outdoors in front of entrance.

"You think this is a Supermarket? Art or not, its food for thought." *Life*, 20 November 1964, 138-44.
Photographs of the *American Supermarket* exhibition with a review by Calvin Tomkins.

"You Bought It, Now Live With It." *Life*, 16 July 1965, 56-61.
Brief commentary on and good color reproductions of the homes of collectors Robert and Ethel Scull, Leon Kraushar, and Harry Abrams, all of whom transformed their homes into Pop Art "galleries."

Volume 20: Studies in the History of Art; Retaining the Original: Multiple Originals, Copies, and Reproductions. Center for Advanced Study in the Visuals Arts/Symposium papers VII, Washington: National Gallery of Art, 1989.
Articles from the symposium "Where Does Originality Lie?," which generated various responses. Claims there are two kinds of multiples: 1. copies of recognized works of art made to possess the original or replicate its iconic or cultural meaning; 2. copies intended to be multiple originals that equally enable possession of the original while replicating and disseminating its image. Included are Rosalind Krauss' "Retaining the Original? The State of the Question" and essays concerned with multiples issues from Greek times to the present.

Zahn, Irena von. "Multiple View." *Art in America* 65, no. 1 (January/February 1977): 41-3.
Provides a thorough history of multiples and discusses various inherent issues, including production costs, critical status of the medium, artist's control, and edition size. Proposes that the production of a multiple is rarely fully controlled by the artist. It is actually an organizational and financial venture requiring a sponsor. Discusses Oldenburg's *Tea Bag* and *Profile Airflow;* the Betsy Ross Flag and Banner Co.; Multiples Inc.; Tanglewood Press, *7 Objects in a Box;* and *Ten From Leo Castelli.*

INTERVIEWS

Rosa Esman, interview by Constance Glenn, Linda Albright-Tomb, and Dorothy Lichtenstein, 1 December 1995, tape recording. Ubu Gallery, New York.

Marian Goodman, interview by Constance Glenn, Linda Albright-Tomb, and Dorothy Lichtenstein, 30 November 1995, tape recording, Multiples Inc., New York.

Dorothy Lichtenstein, interview by Constance Glenn and Linda Albright-Tomb, 1 December 1995, tape recording, New York.

ARCHIVES

Kron, Joan, Papers, 1959-1971. Archives of American Art, Smithsonian Institution.

Sabol, Audrey, Papers, 1962-1964. Archives of American Art, Smithsonian Institution.
Both are invaluable resources. They detail Sabol's and Kron's early involvement with Pop Art and multiples; include *Art 1963—New Vocabulary* and *The Museum of Merchandise,* both at YM/YWHA, Philadelphia; press clippings; correspondence with the artists; records of Durable Dish Co.

BOOKS

Amaya, Mario. *Pop Art...And After.* New York: The Viking Press and London: Studio Vista Limited, 1965.
One of the earliest books written on the subject; provides excellent background. No mention of multiples, although reproduces Lichtenstein's *Pistol* banner.

Archer, Jules. *The Incredible Sixties. The Stormy Years That Changed America.* New York: Harcourt Brace Jovanovich, Publishers, 1986.
Good resource for overall picture of the era. Includes chapters about Vietnam, rock 'n' roll, the Kennedy years, and the sexual and feminist revolutions.

Benjamin, Walter. "The Work of Art in the Age of Mechanical Reproduction" (written in 1935). In *Marxism and Art: Writings in Aesthetics and Criticism,* eds. Berel Lang and Forrest Williams, 281-300. New York: David McKay Company, Inc., 1972.
The seminal work in the field. Discusses the definition of an original work of art and the changes brought about by the introduction of film and photography.

Claes Oldenburg: Drawings and Prints. Introduction by Gene Baro. New York: Chelsea House Publishers, 1969.
A Paul Bianchini book. A catalogue raisonné of Oldenburg's drawings (1958-67) and prints (1960-67). Reproduces sketches related to multiples.

Claes Oldenburg: Multiples in Retrospect 1964-1990. New York: Rizzoli International Publications, Inc., 1991.
Catalogue raisonné of Oldenburg multiples. Includes essay, "Candies and Other Comforts: An Erotics of Care," by T. Lawson and a foreword by Arthur Solway. Offers good color reproductions of all multiples, relevant sketches, as well as Oldenburg's thoughts on each.

Corlett, Mary Lee. *The Prints of Roy Lichtenstein: A Catalogue Raisonné 1948-1993.* New York: Hudson Hills Press, 1994.
Excellent source for information on and color reproductions of selected Lichtenstein multiples, including *Moonscape* (banner); *Seascape; Modern Sculpture with Apertures; Pyramid; Hat; Wallpaper; Wrapping Paper; Turkey Shopping Bag.*

Eagen, Robert. *The 1960s.* Kansas City: Ariel Books, 1994.
A miniature object-like book which provides an outline of the cultural events of the 1960s and includes such topics as fashion, music, politics, television, literature, and more.

Feldman, Frayda and Jörg Schellmann. *Andy Warhol Prints: A Catalogue Raisonné.* New York: Abbeville Press, 1989.
Print catalogue raisonné. Provides catalogue entries and reproductions of *$1.57 Giant Size; Campbell's Soup Can Shopping Bag,* 1964 and 1966; *Cow;* and *Portraits of the Artists.*

Frith, Simon and Howard Horne. *Art Into Pop.* London and New York: Methuen & Co., 1987.
A survey of the art school and rock music scenes in Britain in the 1960s. Discusses the collapse of any distinction between "high" and "low" culture.

Gilmour, Pat. *Understanding Prints: A Contemporary Guide.* London: Waddington Galleries, 1979.
Introduction to the history of prints from before the invention of photography to contemporary times. Covers Èdition MAT and Spoerri, and Arp's 1964 felt multiple shapes (reproduced). Provides quote by Oldenburg on the invention of the multiple.

Howard, Gerald, ed. *The Sixties: The Art, Attitudes, Politics, and Media of our Most Explosive Decade.* New York: Marlowe & Company, 1995.
Writings by such prominent figures of the period as Tom Wolfe, Norman Mailer, James Baldwin, Marshall McLuhan, Elridge Cleaver, et al.

Levin, Kim. *Lucas Samaras.* New York: Harry N. Abrams, Inc., 1975.
Good color reproduction of *Book.*

Livingstone, Marco, ed. *Pop Art.* London: Royal Academy of Arts and Weidenfeld & Nicolson, 1991.
Published on the occasion of the exhibition at the Royal Academy of Arts, September 13 - December 15, 1991. Includes essays by Constance W. Glenn on the early years of American Pop Art. Bibliographical references and index.

Mamiya, Christin J. *Pop Art and Consumer Culture: American Supermarket.* Austin, Texas: University of Texas Press, 1992.
No direct discussion of multiples, although very informative regarding the context out of which Pop Art arose. "The focus of this book. . . will be to explore not only how Pop Art drew upon the mechanisms, imagery, and ideology of consumer culture but also how it contributed to the legitimation of that very system."

Mogelon, A. and N. Laliberté. *Art in Boxes.* New York: Van Nostrand Reinhold, 1974.
An investigation into various types of art boxes. Reproduces Indiana's *Number Box;* Trova's *Study, Falling Man* series and *Folding Man;* Rivers' *Cigars Box.*

Ochoa, George and Melinda Corey. *The Timeline Book of The Arts.* New York: Ballantine Books/The Stonesong Press, Inc., 1995.
Timeline covers painting, decorative arts, photography, architecture, literature, music, and miscellanous events.

Piper, David, ed. *The Illustrated Library of Art.* New York: Portland House, 1986.
Overview of Duchamp, Dada, and Readymades.

Ratcliff, Carter. *Andy Warhol.* New York: Abbeville Press, 1983.
Overview of Warhol's career; provides helpful chronology of his life and exhibitions.

Roy Lichtenstein: Drawings and Prints. Introduction by Diane Waldman. New York: Chelsea House Publishers, 1969.
A Paul Bianchini book. Includes catalogue raisonné of Lichtenstein drawings, prints, and studies. Offers a good, brief history of his print work, including Rowlux/plastic works and multiples illustrated: *Sandwich and Soda; Turkey Shopping Bag; Moonscape; Seascape; Ten Landscapes; Pyramid;* and *Hat.*

Russell, John and Suzi Gablik. *Pop Art Redefined.* London: Thames and Hudson, 1969.
One of the earlier overviews.

Schellmann, Jörg and Bernd Klüser, eds. *Joseph Beuys: Multiples; Catalogue Raisonné Multiples and Prints 1965-80,* 5th ed. New

York: New York University Press, 1980.
Interviews with Beuys (1970 and 1977) precede the raisonné.

Zinsser, William K. *Pop Goes America.* New York: Harper & Row Publishers, 1966.
A look at the Pop phenomenon in the U.S. Author claims a Pop attitude has infiltrated everyday life. Chapter 3, "The Pop Art Collectors," is the most interesting and pertinent. Describes the lifestyle of the Pop collector.

EXHIBITION CATALOGUES

ARS Multiplicata: Vervielfältigte Kunst seit 1945. Cologne: Wallraf-Richartz-Museum in the Kunsthalle, 1968.
In German. Deals primarily with prints of the 1950s and 1960s. Includes the following: Wesselmann's *Cut Out Nude*; Dine's *A Tool Box*; Indiana's *New Glory, Love, Numbers Box*; Lichtenstein's *Turkey Shopping Bag, Seascape*; Oldenburg's *Tea Bag, Knäckebröd*; Rivers' *Cigar Box*; Warhol's *Campbell's Soup Can, Cow, Shopping Bag*; *7 Objects in a Box*; *Ten from Leo Castelli*.

Atkinson, Tracy. *Pop Art and The American Tradition.* Milwaukee Art Center: 1965.
One of the early Pop Art exhibits; reproduces Watts' black and white *Bacon, Lettuce and Tomato Sandwich*.

Beyond The Artist's Hand: Experience of Change. Long Beach: The Art Galleries, California State University, 1976.
A section by Suzanne Paulson is devoted to the many versions of Indiana's *Love.* Also provides an index and bibliography.

Block, René, Marian Goodman, John Loring, et al. *Multiples: An Attempt to Present the Development of the Object Edition.* Berlin: Neuer Berliner Kunstverein, 1974.
In German and English. Claims to be the "first comprehensive exhibition relating to the 'History of the Multiple.'" Goal is to "represent the development of the object edition." Covers Duchamp, Èdition MAT, Beuys, Arte Povera, object-boxes, in addition to Kinetic, Op, Minimal, Conceptual, and Pop Art. Includes the following essays: "Notes as to Purpose, Set-up and Selection of the Exhibition," by René Block; "To Create is Divine, To Multiply is Human," by Marian Goodman and John Loring; "Marcel Duchamp and the Multiple," by Arturo Schwartz; "Time Art in the Household," by Wolfgang Feelisch; "About Multiples," by Beuys/Schellmann/Klüser; "The Book Objects of the Edition Le Soleil Noir," by François Di Dio. In addition to multiples by numerous European artists, includes Indiana's *Numbers Box*; Samaras's *Book*; Oldenburg's *Knäckebröd, Profile Airflow, Tea Bag, Miniature Soft Drum Set, London Knees, Fire Plug*; Lichtenstein's *Seascape*; Rivers' *Cigar Box*; Dine's *Bleeding Heart, Palette I, Landscape Screen*; *7 Objects in a Box, 1969*; *Ten From Leo Castelli*.

Buchholz, Benjamin H.D. *Robert Watts.* New York: Leo Castelli Gallery, in cooperation with Carl Solway Gallery, Cincinnati, 1990.
Documents Watts' early work and participation in the American Supermarket exhibition.

Buchholz, Daniel and Gregorio Magnani, eds. *International Index of Multiples from Duchamp to the Present.* Tokyo: Spiral/Wacoal Art Center, 1993.
Published in conjunction with the 1992 exhibition entitled *Three or More – Multiplied Art from Duchamp to the Present*. Important source, although not comprehensive and at times inaccurate. Includes an introduction by G. Magnani and transcriptions of interviews with four individuals who attempt to define multiples. Includes the primary Pop artists, although listings are incomplete.

Cameron, Dan. *Multiples.* New York: Hirschl & Adler Modern, 1990.
Includes works from the 1960s by 28 European and American artists. Author places multiples in a historical context. Offers a brief discussion of artists in show. Reproduces Rauschenberg's *Shades*, and Warhol's *Campbell's Tomato Juice Boxes*, as well as works by Artschwager, Oldenburg, Beuys, Broodthaers, Christo, Herold, Hesse, Judd, Klein, LeWitt, Nauman, Polke, and Steinbach.

Castleman, Riva. *Technics and Creativity: Gemini G.E.L.* New York: The Museum of Modern Art, 1971.
The boxed book itself contains a multiple by Johns. Provides a history of printmaking and an overview of early multiples production in America and Europe. Discusses and reproduces Oldenburg's

Profile Airflow and Johns' lead reliefs. Good bibliography.

Claes Oldenburg: The Multiples Store. Introduction by Susan May. Exhibition curated by David Platzker and organized by Susan May. London: A National Touring Exhibition organized by The Hayward Gallery, 1996-1997.
An exhibition catalogue derived from the book *Claes Oldenburg: Multiples in Retrospect.*

Claes Oldenburg: Object into Monument. Pasadena, California: Pasadena Art Museum, 1971.
Retrospective of Oldenburg's work from the mid 1960s; focuses heavily on his models and drawings for monuments. Also includes a large collection of his writings. Provides sketches and photographs of *Baked Potato, Knäckebröd, London Knees, Miniature Soft Drum Set*, and *Fire Plug*. In addition, offers Oldenburg's thoughts on each of these projects.

Cvikota, Thomas. *Possibly Overlooked Publications: A re-examination of contemporary prints and multiples.* Chicago: Landfall Gallery, 20 November 1981- 16 January 1982.
A tabloid newspaper catalogue. Includes 1960s multiples by Oldenburg and Ruscha.

Das Jahrhundert des Multiple Von Duchamp bis zur Gegenwart. Essays by Zdenek Felix, Stefan Germer, Claus Pias and Katerina Vatsella. Stuttgart: Oktagon Verlag and Bonn: VG Bild-Kunst, 1995.
In German. Catalogue for an exhibition at the Deichtorhallen, Hamburg, 1994. General overview with special sections devoted to Èdition MAT, kinetic objects, boxes, and the artists Artschwager, Beuys, and Oldenburg. Heavily illustrated; artists biographies.

De Salvo, Donna. *Forces of the Fifties: Selections from the Albright-Knox Art Gallery.* Columbus: Wexner Center for the Arts, The Ohio State University, 1996.

Editions in Plastic. College Park: University of Maryland Art Gallery, 1970.
"An International Survey of Works of Art Involving the Use of Plastic and Published in Editions." Includes Oldenburg's *Tea Bag, London Knees*; Rauschenberg's *Passport*; Rivers' *French Money*; Rosenquist's *Sketch for Forest Ranger*; Warhol's *Banana, Portraits of The Artists*; Wesselmann's *Nude* (banner).

Fairbrother, Trevor J. *Tom Wesselmann: Graphics 1964-1977.* A Retrospective of Work in Edition Form. Boston: Institute of Contemporary Art, 1978.
Discusses some of Wesselmann's unconventional graphics: formed plastic, rubber stamps, embossed paper, banners, stencil drawings, collage, and tapestry. He began producing banners with Betsy Ross Flag and Banner Co. in 1964. Discusses his choice of subject matter.

Fine, Ruth E. *Gemini G.E.L.: Art and Collaboration.* Washington, D.C.: National Gallery of Art, 1984.
Survey of Gemini G.E.L.'s publications from its founding in 1966 to 1984. Strives to describe Gemini's "range and utility." Description of Oldenburg's process regarding *Profile Airflow* plus other later projects. Description of Johns' *Critic Smiles* and *Bread*. Entries on Rauschenberg and Lichtenstein not applicable (either too late or prints).

Fleming, Marie L. *Pop Art: Prints and Multiples.* Ontario, Canada: Art Gallery of Ontario, 1982.
Exhibition of forty-four works by seven Pop artists – three British, four American (Peter Blake, Richard Hamilton, Allen Jones, Lichtenstein, Oldenburg, Rosenquist, Warhol). Nice summary of Pop Art movement and the contributions of both British and American artists. Mentions L. Alloway, the Independent Group, Paolozzi. Includes Oldenburg's *Tea Bag, London Knees, Miniature Soft Drum Set, Profile Airflow*; Lichtenstein's *Fish and Sky*, plus other prints.

Glenn, Constance W. *Roy Lichtenstein: Ceramic Sculpture.* Long Beach: University Art Museum, California State University, 1977.
Includes Lichtenstein's *Dishes, Cloisonné Pendant, Study for Paper Plate.*

Goldman, Judith, et al. *The Pop Image: Prints and Multiples.* New York: Marlborough Graphics/Marlborough Gallery, Inc., 1994.
Excellent resource. Includes essay and color reproductions of D'Arcangelo's *Side-View Mirror*; Lichtenstein's *Dishes*; Oldenburg's *London Knees, Profile Airflow, Baked Potato*; Rivers' *Cigar Box*; and Wesselmann's *Little Nude*. Also includes artists' biographies,

checklist with black and white images, index to the artists, glossary of publishers and workshops, reprinted articles on Pop Art, and a selected bibliography.

Haskell, Barbara. *Blam! The Explosion of Pop, Minimalism, and Performance 1958-1964.* New York: Whitney Museum of American Art, 1984.
Offers a helpful chronology of events, including exhibitions and reviews, Happenings, performances, and films.

Herzka, Dorothy (Lichtenstein). *Pop Art One.* New York: Publishing Institute of American Art, 1965.
A small multiple itself, conceived while Dorothy Herzka worked at the Bianchini Birillo Gallery. Contains works from the *Supermarket* exhibition, including Johns' *Painted Bronze* and Warhol's *Brillo Box.*

Hickey, Dave and Peter Plagens. *The Works of Edward Ruscha.* New York: Hudson Hills Press in association with the San Francisco Museum of Modern Art, 1982.
Provides background for Ruscha's books.

Hopps, Walter. *Boxes.* Los Angeles: Dwan Gallery, 1964.
Illustrates Warhol's *Heinz Tomato Ketchup* and *Brillo Boxes* in what is arguably their first display, 2-29 February 1964.

Jacobsen, Marjory and Judith Hoos Fox. *The Multiple Object.* Boston: Bank of Boston Gallery, 1988.
Defines the term multiple; gives brief history. Includes Rauschenberg's *Shades*; Johns' *The Critic Smiles*; Oldenburg's *Miniature Soft Drum Set*; Warhol's *Kellogg's.*

Jim Dine: Complete Graphics. Berlin: Galerie Mikro, 1970.
Includes *Boot Silhouettes*; *Bleeding Heart with Ribbons and a Movie Star*; *Palette I*; *Landscape Screen.*

Jim Dine: The Summers Collection. La Jolla, California: La Jolla Museum of Contemporary Art, 1974.
Includes *Landscape Screen*; *Boot Silhouettes*; and various palettes.

Klüver, Billy, et al. *Art 1963—A New Vocabulary.* Philadelphia: Arts Council of the YM/YWHA, 1962.
One of the earliest Pop Art exhibitions outside of New York.

Lane, Hilary and Andrea Patrizio. *Art Unlimited: Multiples of the 1960s and 1990s from the Arts Council Collection.* London: The South Bank Centre, 1994.
A National Touring Exhibition. Fully illustrated catalogue with an excellent historical overview of multiples. Primarily European focus. Essay on the 1960s by Hilary Lane, "To create is divine, to multiply is human (Man Ray)." Article on the 1990s by Andrew Patrizio, "Multiples Today: A Consumer's Guide." Reproductions of Lichtenstein's *Pyramid*, Oldenburg's *London Knees.* Good bibliography.

Oldenburg: Works in Edition. Los Angeles: Margo Leavin Gallery, 1971.
Includes sections on prints, books and film, objects and constructions, and posters. No text, but reproductions of most of his major multiples: *Tea Bag, Baked Potato, Knäckebröd, London Knees, Miniature Soft Drum Set, Profile Airflow.* Photograph of Oldenburg with *Wedding Souvenir* and various post-1960s works.

Rauschenberg: Graphic Art. Philadelphia: Institute of Contemporary Art, University of Pennsylvania, 1970.
Survey of his graphic work. Essay by Lawrence Alloway. Reproductions of *Shades* and *Passport.*

Ruhé, Harry. *Multiples, et cetera.* Amsterdam: Tuja Books, 1991.
European focus. Includes the following essays: "A Shop for Art Editions and What Happened Before," "The 'Kartons' by Armin Hundertmark," "Artists' Books, Object Books and Book Objects," "The Booklet Makers in Iceland," "The Archive," "Posters and Prints," "Learn to Read Art," as well as a bibliography.

Tancock, John L. *Multiples: The First Decade.* Philadelphia: Philadelphia Museum of Art, 1971.
Only major American museum exhibition devoted exclusively to multiples; international in scope. The catalogue itself is a multiple object. Places multiples in a democratic context. Credits Duchamp, Vasarely, Man Ray, Spoerri. Reproductions of Lichtenstein's *Pistol*; Dine's *Picture of Dorian Gray*; Artschwager's *Locations*; Lindner's *Banner No. 1*; Oldenburg's *Miniature Soft Drum Set*; Trova's *Falling Man Suspended Relief.*

Ten from Rutgers. New York: Bianchini Gallery, 1966.
A project at the Bianchini Gallery following the *American Supermarket*; features early work by Watts, Lichtenstein, et al.

Three →: ∞: New Multiple Art. London: Whitechapel Art Gallery/Arts Council of Great Britain, 1970.
Includes the following essays: "Anti-Multiples," by Janet Daley; "What Should Art Cost?" by Karl Gerstner; "Aesthetics of the Yellow Pages," by Reyner Banham; "Art, Beauty and Creation," by Jiddu Krishnamurti; "Towards Workers' Control," by Anthony Wedgwood Benn; "Love of Art," by John Berger. Exhibition includes "works realized by techniques unfamiliar in an art context." Focuses on those which were either "produced in 'unlimited' quantities" or were made using processes which were suitable for "potentially unlimited runs." Also includes prints. Incorporates work by many Europeans as well as D'Arcangelo's *Side-View Mirror*; Dine's *Rainbow Faucet*, *Bleeding Heart*; Indiana's *Love*; Lichtenstein's *Dishes* (photo) and *Modern Head Brooch*; Oldenburg's *Tea Bag, London Knees, Fire Plug, Miniature Soft Drum Set*; Ruscha's *Twentysix Gasoline Stations, Various Small Fires*, plus seven other books; Samaras' *Book*; Trova's *Folding Man*; Warhol's *Cow* and *Index Book*; Wesselmann's *Cut Out Nude*, and *7 Objects in a Box*, 1969.

Following pages: Andy Warhol, *Portraits of the Artists*, 1967 (cat. no. 94) © 1997 The Andy Warhol Foundation for the Visual Arts/Artists Rights Society (ARS), NY

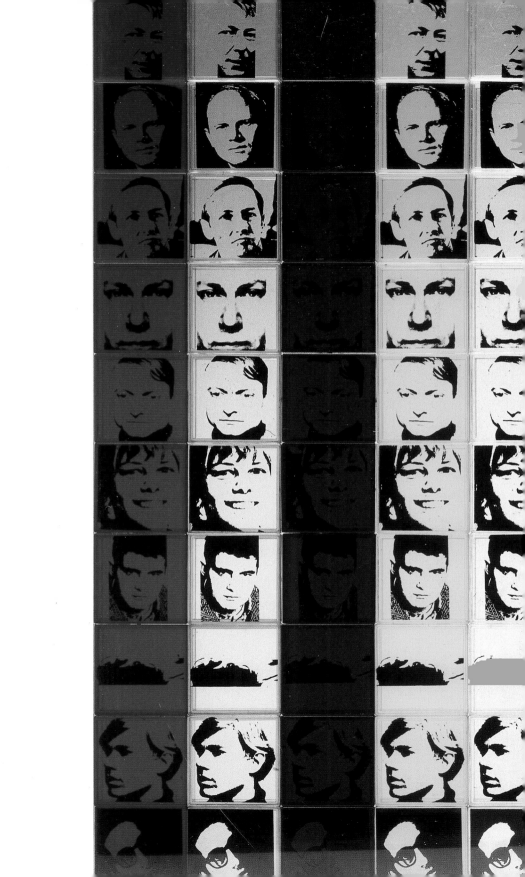

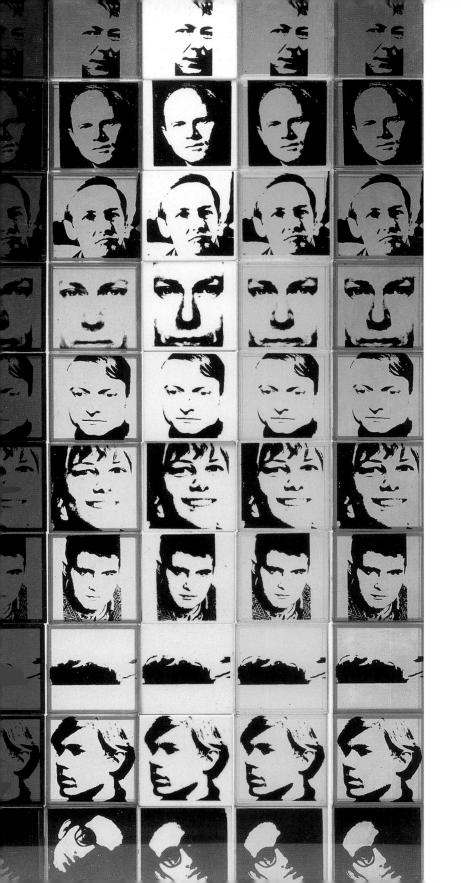

CATALOGUE OF THE EXHIBITION

Dimensions are given in inches and centimeters, height preceding width preceding depth; the fabricator, if known, is followed by the workshop and/or publisher.

ALLAN D'ARCANGELO (b. 1930, Buffalo, New York)

1 **Side-View Mirror** (prototype), 1965
Handpainted Plexiglas in metal side-view mirror,
mounted on Plexiglas base
7 1/2 x 4 x 4 (19.1 x 10.2 x 10.2 cm)
Unique prototype for the edition by Tanglewood
Press Inc., New York
Collection Jon and Joanne Hendricks

2 **Side-View Mirror,** 1966 (from **7 Objects in a Box**)
Screened Plexiglas in metal side-view mirror,
mounted on Plexiglas base
7 1/2 x 4 x 4 (19.1 x 10.2 x 10.2 cm)
Edition 75 numbered, 25 lettered
Fabricated by Knickerbocker Machine & Foundry, New York
Tanglewood Press Inc., New York
Collection Rosa and Aaron H. Esman

JIM DINE (b. 1935, Cincinnati, Ohio)

3 **The Popular Image Exhibition**, 1963
Cover designed by Dine for record which accompanied the
catalogue of **The Popular Image Exhibition**,
The Washington Gallery of Modern Art
12 1/4 x 12 1/4 (31.2 x 31.2 cm)
Offset printing on paper
Edition unknown
Collection Billy Klüver

4 **Boot Silhouettes,** 1966
Felt banner
58 x 55 (147.3 x 139.7 cm)
Edition 20 projected, number realized unknown
Fabricated by Abacrome, New York
Betsy Ross Flag and Banner Company/Multiples Inc., New York
Courtesy Multiples Inc., New York

5 **Rainbow Faucet,** 1966 (from **7 Objects in a Box**)
Cast aluminum with painted drop
5 1/2 x 2 3/4 (14 x 7 cm)
Edition 75 numbered, 25 lettered
Fabricated by Knickerbocker Machine & Foundry, New York
Tanglewood Press Inc., New York
Collection Rosa and Aaron H. Esman

6 **Bleeding Heart with Ribbons and a Movie Star,** 1968
Screenprint on Chrisbook handmade paper, paper, blockprint,
collage, and ribbons in a plastic box
19 1/2 x 14 1/2 x 1 1/4 (49.5 x 36.8 x 3.2 cm)
Edition 48
Petersburg Press, London
Collection Brad and Karen Lowe

7 **The Picture of Dorian Gray (Study for Dorian Gray Poster)**, 1968
Ink and gouache on paper
30 x 22 (76.2 x 55.8 cm)
Collection of the Artist

8 **The Picture of Dorian Gray,** Editions A and B, 1968
Book with lithographs and etchings in varying
combinations
Edition A: Book with 12 lithographs, book signed;
red velvet cover
Edition B: Book with 12 lithographs, book signed;
green velvet cover
17 3/4 x 12 1/2 x 1 (45 x 31.7 x 2.5 cm) each,
boxed book only
Edition A 200; Edition B 200; Edition C 100;
Supplementary Edition 75
Petersburg Press, London
Collection of the Artist

9 **Red Design for Satin Heart,** 1968
From **The Picture of Dorian Gray**
Etching
17 3/4 x 12 1/4 (45 x 31.1 cm)
Edition B 200
Petersburg Press, London
Collection of the Artist

10 **Palette (Joan) #1,** 1964
Pencil, watercolor, oil, and collage on board
29 x 23 (73.7 x 58.4 cm)
Collection Brad and Karen Lowe

11 **Palettes I-IV,** 1969
Palette I
Wood handcolored with acrylic paint
Palette II
Screenprint on Kromecote
Palette III
Etching on Fabriano
Palette IV
Lithograph on Fabriano
28 x 20 (71.1 x 50.8 cm) each
Edition 75 each
Petersburg Press, London
Collection Brad and Karen Lowe

12 **Landscape Screen (5 panels)**, 1969
Screenprint on linen on stretcher
71 1/4 x 89 1/4 (181 x 226 cm)
Edition 30
Petersburg Press, London
Collection of the Artist

ROBERT INDIANA (b. Robert Clark, 1928, New Castle, Indiana)

13 **New Glory,** 1966
Felt banner
87 1/2 x 51 1/2 (222.3 x 130.8 cm)
Edition 20 projected, number realized unknown
Fabricated by Abacrome, New York
Betsy Ross Flag and Banner Company/Multiples Inc.,New York
Courtesy Multiples Inc., New York

14 **Love Ring,** 1968
© Robert Indiana 1968
18 karat gold
13/16 x 13/16 x 3/8 (2 x 2 x1 cm)
Edition 100
Fabricated by Gordon Russell
Commissioned by Audrey Sabol and Joan Kron for the Rare
Ring Co., a division of the Beautiful Bag and Box Co.,
Philadelphia
Collection Joan Kron

JASPER JOHNS (b. 1930, Augusta, Georgia)

15 **Flag,** 1969
Lead relief, sheet lead
17 x 23 (43.2 x 58.4 cm)
Edition 60
Printed by Kenneth Tyler
Gemini G.E.L., Los Angeles
Courtesy Gemini G.E.L., Los Angeles

16 **High School Days,** 1969
Lead relief, sheet lead, and glass mirror
23 x 17 (58.4 x 43.2 cm)
Edition 60
Printed by Kenneth Tyler
Gemini G.E.L., Los Angeles
Courtesy Gemini G.E.L., Los Angeles

17 **The Critic Smiles,** 1969
Lead relief, sheet lead, gold casting, and tin leafing
23 x 17 (58.4 x 43.2 cm)
Edition 60
Printed by Kenneth Tyler
Gemini G.E.L., Los Angeles
Courtesy Gemini G.E.L., Los Angeles

18 **Light Bulb,** 1969
Lead relief, sheet lead
39 x 17 (99.1 x 43.2 cm)
Edition 60
Printed by Kenneth Tyler
Gemini G.E.L., Los Angeles
Courtesy Gemini G.E.L., Los Angeles

19 **Bread,** 1969
Lead relief, cast lead, sheet lead, paper, and oil paint
23 x 17 (58.4 x 43.2 cm)
Edition 60
Printed by Kenneth Tyler
Gemini G.E.L., Los Angeles
Courtesy Gemini G.E.L., Los Angeles

ROY LICHTENSTEIN (b. 1923, New York, New York)

20 **Pistol,** 1964
Felt banner
81 1/4 x 43 (206.3 x 109.2 cm)
Edition 20 projected, number realized unknown
Betsy Ross Flag and Banner Company, New York
Private Collection

21 **Turkey Shopping Bag,** 1964
Screenprint in yellow and black, or yellow and red, on smooth, white wove paper bag with handles
19 5/16 x 17 1/16 (49 x 43.4 cm) variable, bag without handles
Edition approximately 125-200 (estimates vary)
Printed by Ben Birillo (he notes he was assisted by his wife and a number of friends)
Published for *American Supermarket* exhibition, Bianchini Gallery, New York
Courtesy O.K. Harris, New York

22 **Pendant,** 1965
Gold and cloisonné enamel
3 1/2 x 2 1/2 (8.9 x 6.3 cm) teardrop
Edition unknown, possibly 3
Fabricated by Kulicke Cloisonné Workshop, New York
Multiples Inc., New York
Private Collection

23 **Seascape (II),** 1965 (from **Collection 65**)
Screenprint and die-cut collage on blue Rowlux
13 3/16 x 24 15/16 x 3 5/8 (33.5 x 63.3 x 9.1 cm)
Edition 100 (of which approximately 65 were realized)
Fabricated for Galerie Der Spiegel, Cologne
Édition MAT, Cologne
Private Collection

24 **Sunrise,** 1966 (from **7 Objects in a Box**)
Enameled plaque
8 1/2 x 11 x 1 (21.6 x 27.9 x 2.5 cm)
Edition 75 numbered, 25 lettered
Fabricated by Knickerbocker Machine & Foundry, New York
Tanglewood Press Inc., New York
Collection Rosa and Aaron H. Esman

25 **Process Patterns for Dishes,** 1966
Mixed media
30 1/4 x 34 3/4 (76.8 x 88.3 cm)
Produced by Jackson China Co., Syracuse, New York
Private Collection

26 **Dishes,** 1966
Glazed ceramic with black and white design
Six-piece place setting: dinner plate 10 1/4 (26 cm); salad plate 8 (20.3 cm); bread and butter plate 6 1/2 (16.5 cm); soup 8 1/2 (21.6 cm); cup; 2 1/2 x 3 3/4 (6.4 x 9.5 cm); saucer 6 (16 cm)
Edition 800 place settings
Produced by Jackson China Co., Syracuse, New York
Commissioned by Audrey Sabol and Joan Kron for the Durable Dish Company, Villanova, Pennsylvania, a division of the Beautiful Bag and Box Co., Philadelphia
Private Collection

27 **Modern Sculpture with Apertures,** 1967
Screenprinted enamel on interlocking Plexiglas forms with mirrored silver Mylar
16 1/2 x 6 x 7 1/2 (41.9 x 15.2 x 19 cm)
Edition 200
Fabricated by Maurel Studios, New York, collaborator Shelia Marbain
Published by the artist for Artists for Scholarship, Education, and Defense Fund for Racial Equality
Collection Kimiko and John Powers

28 **Thunderbolt,** 1968
Felt banner
101 x 44 1/2 (256.5 x 113 cm)
Edition 20 projected, number realized unknown
Fabricated by Abacrome, New York
Betsy Ross Flag and Banner Company/Multiples Inc., New York
Collection David and Mitchell Lichtenstein

29 **Button for CORE,** c. 1968
Plastic, paper, and metal
1 5/8 diameter (3 cm)
Edition unknown
Collection University Art Museum, CSULB
Gift of Mr. Ben Birillo

30 **Modern Tapestry,** 1968
Wool (handwoven pile)
107 1/2 x 145 (273 x 368.3 cm)
Edition 20; signature verso is misspelled
Modern Master Tapestries, New York
Private Collection

31 **Study for Modern Head Pendant (Modern Head Brooch/Pendant),** 1968
Pencil on paper
4 15/16 x 3 3/8 (12.5 x 8.6 cm)
Framed with **Drawing—Modern Head Pendant,** 1970
Private Collection

32 **Drawing—Modern Head Pendant,** 1970
Pencil on paper
4 15/16 x 3 7/16 (12.5 x 8.8 cm)
Framed with **Study for Modern Head Pendant,** 1968
Private Collection

33 **Modern Head Brooch/Pendant,** 1968
Enamel on metal; red, yellow, and blue (also exists in black and
silver version)
3 x 2 3/8 (7.6 x 6 cm)
Edition unknown
Fabricated by David Lane, New York
Multiples Inc., New York
Collection The Grinstein Family

34 **Hat,** 1968 (from **S.M.S.**, No. 4, August 1968)
Offset lithograph in red, yellow, and blue printed on
both sides of a thin, white plastic sheet, sandwiched in
transparent plastic, and hand-folded to form a tri-cornered hat
19 1/4 x 14 (48.9 x 35.6 cm) unfolded
Edition 2000
Printed by Bernard Reitkopf, Omega Graphics, New York
The Letter Edged in Black Press Inc., New York
Collection University Art Museum, CSULB

35 **Drawing for Salute to Airmail**, 1968
Pencil on paper
25 x 20 (63.5 x 50.8 cm)
Private Collection

36 **Salute to Airmail,** 1968
Polished bronze
5 3/4 x 3 7/16 x 1 7/16 (14.6 x 8.7 x 3.6 cm) with base
Edition 150 (50 chrome, 50 chrome-plated copper, 50 polished
bronze)
The International Collectors Society, New York
Courtesy O.K. Harris, New York

37 **Study for Wallpaper,** 1968
Pencil and colored pencil on paper
6 x 4 (15.2 x 10.1 cm), image only
Framed with **Study for Wrapping Paper,** 1968
Collection Mitchell Lichtenstein

38 **Wallpaper,** 1968
Screenprint in white, yellow, red, and black on fabric-backed
metallic foil
29 7/8 x 27 3/4 (76.2 x 70.4 cm), one repeat; two repeats
shown
Edition unknown
Printer unknown, possibly Artmongers Manufactory, New York
Bert Stern, for On 1st, New York
Private Collection

39 **Study for Wrapping Paper,** 1968
Pencil and colored pencil on paper
6 x 6 (15.2 x 15.2 cm), image only
Framed with **Study for Wallpaper,** 1968
Collection Mitchell Lichtenstein

40 **Wrapping Paper,** c.1968
Screenprint in yellow, red, and black on glossy white paper
15 5/8 x 14 3/4 (39.6 x 37.4 cm), one repeat (the same
composition as **Wallpaper,** with color modifications), multiple
repeats shown
Edition unknown
Printer unknown, possibly Artmongers Manufactory, New York
Bern Stern, for On 1st, New York
Private Collection
Without regard to previous display or publication, **Wallpaper**
and **Wrapping Paper** (nos. 37-40) are oriented here in
accordance with the artist's wishes

41 **Paper Plate,** 1969 (complete package shown)
Screenprint in yellow, red, and blue on white paper plate
10 1/4 diameter (26 cm) each plate
Edition unknown (originally clear cellophane-wrapped in
packages of 10)
Printer unknown, possibly Artmongers Manufactory, New York
Bert Stern, for On 1st, New York
Collection University Art Museum, CSULB

CLAES OLDENBURG (b. 1929, Stockholm, Sweden)

42 **California Ray Guns,** 1963-64
Vacuum-formed acetate
8 x 11 x 2 (20.3 x 27.9 x 5.1 cm) variable without flange, each
Edition unknown (2 sets of six, 3 sets of four remaining from an
unrecorded number produced), all unsigned and numbered
Unpublished
California Ray Gun: Seahorse, Rabbit
California Ray Gun: Angel, "God is Love"
California Ray Gun: Horse, Wing
California Ray Gun: Cleopatra's Hair, Boy with Cap
California Ray Gun: Bear, Woman, Fish
California Ray Gun: Bell, Book, Fruit
Collection Claes Oldenburg and Coosje van Bruggen

43 **Baked Potato,** 1966 (from **7 Objects in a Box**)
Cast resin, painted with acrylic; Shenango china dish
7 x 10 1/2 x 4 1/2 (17.8 x 26.7 x 11.4 cm)
Edition 75 numbered, 25 lettered
Fabricated by Knickerbocker Machine & Foundry, New York
Details handpainted by the artist
Tanglewood Press Inc., New York
Collection Rosa and Aaron H. Esman

44 **Notebook Page: Dropped Tea Bag,** 1965
Clipping and ball point pen on paper
11 x 8 1/2 (27.9 x 21.6 cm)
Collection Claes Oldenburg and Coosje van Bruggen

45 **Tea Bag,** 1966 (from **Four on Plexiglas**)
Vinyl, serigraph on Plexiglas, felt, rayon cord
39 x 28 x 3 1/2 (99.1 x 71.1 x 8.9 cm)
Edition 125 numbered, 16 lettered
Fabricated by Knickerbocker Machine & Foundry, New York
Multiples Inc., New York
Collection Kimiko and John Powers

46 **Notebook Page: Assorted Slices of Cake,** 1965
Clipping, felt pen, ballpoint pen, and pencil on paper
11 x 8 1/2 (27.9 x 21.6 cm)
Collection Claes Oldenburg and Coosje van Bruggen

47 **Wedding Souvenir,** 1966
Cast plaster
5 3/4 x 6 1/2 x 2 1/2 (14.6 x 16.5 x 6.4 cm)
Edition approximately 200 plain, 72 silver
Executed at Beryl's Studio, Santa Monica
Commissioned by James Elliott for the wedding of Judith and
James Elliott, April 23, 1966
Collection The Grinstein Family

48 **Knäckebröd,** 1966
Cast iron
3/4 x 6 1/2 x 3 3/4 (1.9 x 16.5 x 9.5 cm)
Edition 250
Fabricated by Liljeholmens Gjuteri, Spånga, Sweden
Moderna Museet, Stockholm
Collection The Grinstein Family

49 **Store Days: Documents from the Store (1961)**
and Ray Gun Theater (1962), 1967
Offset lithographic artist's book printed in four colors
11 1/8 x 8 1/2 (28.3 x 21.6 cm)
First Edition 5000 unnumbered, unsigned copies
Second Edition 3000 (1968) unnumbered, unsigned copies
Something Else Press, New York
Collection Claes Oldenburg and Coosje van Bruggen

50 **Notebook Page: Study for London Knees Box,** 1966
Felt pen and ballpoint pen on paper
11 x 8 1/2 (27.9 x 21.6 cm)
Collection Claes Oldenburg and Coosje van Bruggen

51 **Proposed Colossal Monument: Leg For Thames Estuary; Low Tide,** 1966
Pencil, watercolor, and crayon
15 x 22 (38.1 x 55.8 cm)
Collection Kimiko and John Powers

52 **London Knees 1966,** 1968
Cast latex painted with colored polyurethane, felt, and cast acrylic; twenty-one offset lithographs on paper; cloth-covered traveling case
Knees: 15 x 6 x 5 1/2 each (38.1 x 15.2 x 14 cm)
Stand: 1 x 16 x 10 1/2 (2.5 x 40.6 x 26.7 cm)
Prints: 16 x 10 1/2 (40.6 x 26.7 cm)
Case: 11 1/2 x 17 x 7 1/2 (29.2 x 43.2 x 19.1 cm)
Edition 120
Fabricated by various shops in London and Surrey
Editions Alecto, London, in association with
Neuendorf Verlag, Berlin
Collection Kimiko and John Powers

53 **Design for Tunnel Entrance in the Form of a Nose (Used for Documenta 4 Handkerchief),** 1968
Crayon
29 x 23 (73.6 x 58.4 cm)
Collection Kimiko and John Powers

54 **Nose Handkerchief,** 1968
Silkscreen on silk handkerchief
19 x 19 (48.3 x 48.3 cm)
Edition 150
Printed by H.P. Haas, Stuttgart, Germany
Documenta Foundation, Kassel, Germany
Collection Claes Oldenburg and Coosje van Bruggen

55 **Notebook Page: Snapshots of Chicago Fireplug,** 1968
Photographs and pencil on paper
11 x 8 1/2 (27.9 x 21.6 cm)
Collection Claes Oldenburg and Coosje van Bruggen

56 **Fire Plug Souvenir - "Chicago August 1968,"** 1968
Cast plaster, acrylic paint
8 x 8 x 6 (20.3 x 20.3 x 15.2 cm)
Edition 100
Fabricated by Sculpture Center, Inc., New York
Richard Feigen Gallery, Chicago
Collection The Grinstein Family

57 **Profile Airflow,** 1969
Molded polyurethane relief over two-color lithograph on Special Arjomari paper in aluminum frame
33 1/2 x 65 1/2 x 4 (85.1 x 166.4 x 10.2 cm)
Edition 75
Polyurethane fabricated by CalPolymers, Los Angeles
Collaborators Kenneth Tyler, Jeff Sanders, Richard Wilke
Gemini G.E.L., Los Angeles
Courtesy Gemini G.E.L., Los Angeles

58 **Profile Airflow—Test Mold, Front End,** 1968-72
Molded polyurethane relief over one-color silkscreen on Plexiglas in aluminum frame
18 1/2 x 15 5/8 x 4 (47 x 39.7 x 10.2 cm)
Edition 50
Polyurethane fabricated by CalPolymers, Los Angeles
Collaborators Kenneth Tyler, Jeff Sanders, Gary Reams, Peter Carlson, Jeff Wasserman
Gemini G.E.L., Los Angeles
Courtesy Gemini G.E.L., Los Angeles

59 **Miniature Soft Drum Set,** 1969
Serigraph on canvas, washline, wood, spray enamel, and wood covered with serigraphed paper
9 3/4 x 19 x 13 3/4 (24.8 x 48.3 x 34.9 cm) variable
Edition 200
Screenprinting by Maurel Studios, New York
Sewing, assembly, and rope parts by Abacrome, New York
Fabrication of wood parts by Red Palardy at Chelsea Model and Cabinet Shop,New York
Details handpainted by the artist
Multiples Inc., New York
Courtesy Multiples Inc., New York

ROBERT RAUSCHENBERG (b. 1925, Port Arthur, Texas)

60 **Passport,** 1967 (from **Ten From Leo Castelli,** 1968)
Colored silkscreen on three rotating plastic discs
20 diameter (50.8 cm)
Edition 200 numbered, 25 lettered
Fabricated by Fine Art Creations, Inc., New York
Tanglewood Press Inc., New York
Collection Kimiko and John Powers

61 **Revolver,** 1969 (from **Artists and Photographs,** 1970)
Five Plexiglas disks with screenprints in color
8 diameter (20.3 cm)
Edition 1000 projected; number realized unknown
Multiples Inc., New York, with Colorcraft, Inc., New York
Courtesy Multiples Inc., New York

LARRY RIVERS (b.1923, Bronx, New York)

62 **Cigar Box,** 1967
Painted wood object, silkscreen on lid
13 1/4 x 16 x 13 1/4 (33.7 x 40.6 x 33.7 cm)
Edition 20
Multiples Inc., New York
Courtesy Multiples Inc., New York

JAMES ROSENQUIST (b. 1933, Grand Forks, North Dakota)

63 **Small Doorstop,** 1963-67
Screenprint on canvas with light bulbs and fixtures
24 x 36 x 10 (61 x 91.4 x 25.4 cm)
Edition 10
Published by the artist
Collection of the Artist

64 **Sketch for Forest Ranger,** 1967
(from **Ten from Leo Castelli,** 1968)
Free-hanging silkscreen on two die-cut vinyl sheets
24 x 20 1/4 (61 x 51.4 cm)
Edition 200 numbered, 25 lettered
Fabricated by Fine Creations, Inc., New York
Tanglewood Press Inc., New York
Collection of the Artist

65 **Baby Tumbleweed,** 1968
Neon light, chromed barbed-wire construction; white Formica base
16 x 12 x 11 (40.6 x 30.5 x 27.9 cm)
Edition 12
Published by the artist
Collection of the Artist

EDWARD RUSCHA (b. 1937, Omaha, Nebraska)

66 **Standard,** 1962
Tempera on paper
9 1/4 x 15 3/4 (23.5 x 40 cm)
Collection of the Artist

67 **Standard Study,** 1962
Tempera on paper
5 3/8 x 10 1/8 (13.7 x 46 cm)
Collection of the Artist

68 **Study for Standard Station, Amarillo, Texas,** 1962-63
Ink and pencil on paper
9 5/8 x 13 3/4 (24.4 x 34.9 cm)
Collection of the Artist

69 **Twentysix Gasoline Stations,** 1963
Printed softbound book
7 x 5 1/2 x 1/4 (17.8 x 14 x .6 cm)
First edition 400 numbered; second edition (1967) 500; third
edition (1969) 3000
Published by the artist
Collection of the Artist

70 **Some Los Angeles Apartments,** 1965
Printed softbound book
7 x 6 x 1/4 (17.8 x 15.2 x .6 cm)
First edition 700; second edition (1970) 3000
Published by the artist
Collection of the Artist

71 **Every Building on the Sunset Strip,** 1966
Printed softbound book with foldout
7 1/4 x 5 3/4 x 5/8 (18.4 x 14.6 x 1.6 cm)
First edition 1000; second edition (1969) 500; third edition
(1971) 5000
Published by the artist
Collection of the Artist

72 **Business Cards,** 1966
Printed softbound book with photograph and calling card
attached; collaboration with Billy Al Bengston
8 3/4 x 5 3/4 x 1/4 (22.2 x 14.6 x .6 cm)
Edition 1000, signed by the artists
Published by the artist
Collection of the Artist

73 **Billy,** 1968
Catalogue designed for an exhibition of the work of
Billy Al Bengston
9 x 11 x 1/4 (22.8 x 25.4 x .63 cm)
Pink flocking on book cover; bound by two metal screws and
washers, with pink satin ribbon placemarker
Edition 2500
Printed by Toyo Press, Los Angeles
Flocking by O'Kay Embroidery
Binding by Keystone Bolt & Supply Co.
Los Angeles County Museum of Art
Collection of the Artist

LUCAS SAMARAS (b. 1936, Kastoria, Macedonia, Greece)

74 **Book,** 1968
Die-cut book-object in 98 colors with screenprinting, lithography
and embossing, containing six stories by the artist, fold outs,
and small books
10 x 10 x 2 1/4 (25.4 x 25.4 x 5.7 cm)
Edition 100
Pace Editions, New York
Courtesy Pace Editions, New York

GEORGE SEGAL (b. 1924, New York, New York)

75 **Chicken,** 1966 (from **7 Objects in a Box**)
Cast acrylic and fiberglass
17 1/2 x 13 x 5 (44.5 x 33 x 12.7 cm)
Edition 75 numbered, 25 lettered
Fabricated by Knickerbocker Machine & Foundry, New York
Tanglewood Press Inc., New York
Collection Rosa and Aaron H. Esman

WAYNE THIEBAUD (b. 1920, Mesa, Arizona)

76 **Delights,** 1964
Portfolio of 17 etchings, bound, black with
gold lettering
12 7/8 x 11 (32.7 x 27.9 cm)
Edition 100, approximately 50 bound
Crown Point Press, San Francisco
Collection of the Artist

77 **Cafeteria Counter,** 1964-1990
Watercolor over hardground etching
12 7/8 x 11 (32.7 x 27.9 cm)
Edition A.P. from **Delights,** 1964
Crown Point Press, San Francisco
Courtesy Campbell-Thiebaud Gallery, San Francisco

78 **Boston Cream Pie** (pin), 1965
Gold and cloisonné enamel
7/8 diameter (2.2 cm)
Edition possibly 3; sizes vary
Kulicke Cloisonné Workshop, New York
Collection Betty Jean Thiebaud

ERNEST TROVA (b. 1927, St. Louis, Missouri)

79 **Falling Man Banner,** 1968
Felt, linen, and canvas banner
70 x 72 (177.8 x 182.88 cm)
Edition 20 projected, number realized unknown
Fabricated by Abacrome, New York
Betsy Ross Flag and Banner Company/Multiples Inc., New York
Courtesy Multiples Inc., New York

ANDY WARHOL (b. Andrew Warhola, 1928, McKeesport,
Pennsylvania—d.1987, New York City)

80 **$1.57 Giant Size,** 1963
Screenprint on coated record-cover stock, first sprayed with an
unknown number of different Day-Glo colors (more than four), a
few not sprayed, remaining white. Record includes interviews
with artists who participated in **The Popular Image Exhibition,**
The Washington Gallery of Modern Art.
12 1/4 x 12 1/4 (31.2 x 31.2 cm)
Edition 75, signed and numbered in pen on verso, and an
unknown number unsigned and unnumbered
Printed by Andy Warhol and Billy Klüver
Published by Billy Klüver
Collection Billy Klüver

81 **Brillo Box** (8), 1969
Acrylic silkscreen on wood box
20 x 20 x 17 (50.8 x 50.8 x 43.1 cm)
Eight boxes selected from the 100 made for the 1970
Pasadena Art Museum retrospective (Warhol made Brillo and
other food/product boxes from approximately December 1963
throughout the decade, in varying sizes and colors)
Collection Norton Simon Museum, Pasadena
Gift of the Artist, 1969

82 **Campbell's Soup Can,** ca. 1965
Aluminum can with lacquer label
4 x 2 5/8 (12.5 x 8.2 cm)
One of a group originally thought to include at least 10 hand-
lathe-turned aluminum cans and 1 hand-lathe-turned bronze can;
it is now apparent that there exists a small number of additional
cans with a total of 2 rather than 1 bronze
Fabricated under the direction of Ben Birillo
Collection The Andy Warhol Foundation for the
Visual Arts, New York

83 **Campbell's Soup Can Shopping Bag,** 1964
Color screenprint on smooth, white wove paper bag
with handles
19 5/16 x 17 1/16 (49 x 43.4 cm) variable; bag
without handles
The catalogue raisonné (Feldman/Schellmann) places the
edition at 300; the printer believes the number to be
approximately 125-200
Printed by Ben Birillo
Published for **American Supermarket** exhibition,
Bianchini Gallery, New York
Collection Benjamin Birillo II

84 **Campbell's Soup Can Shopping Bag,** 1966
Color screenprint on shopping bag
19 5/16 x 17 1/16 (49 x 43.4 cm)
Edition unknown
Institute of Contemporary Art, Boston
Collection Norton Simon Museum, Pasadena
Gift of Mr. Irving Blum, 1969

85 **Silver Clouds,** 1966 *
Helium-filled silver Mylar sacks (one vintage shown)
49 x 35 (124.4 x 88.9 cm) each
An unknown number was manufactured
Collection The Grinstein Family
*Modern replica installation, courtesy The Andy Warhol
Museum, Pittsburgh; not at all venues

86 **Silver Clouds,** 1966
Depicted in a photograph by Stephen Shore entitled
Andy Warhol, New York City, 1966
Gelatin silver print
13 15/16 x 10 7/8 (33.2 x 27.3 cm)
Collection University Art Museum, CSULB

87 **Campbell's Soup Can Banner,** 1966
Felt appliqué
89 x 60 (226.1 x 152.4 cm)
Edition 20 projected, number realized unknown
Betsy Ross Flag and Banner Company/Multiples Inc., New York
Courtesy Multiples Inc., New York

88 **Kiss,** 1966 (from **7 Objects in a Box**)
Filmstrip screenprint from Warhol's 1963 film **Kiss,** printed on
Plexiglas with stand
12 1/2 x 8 1/4 x 5 1/4 (31.8 x 21 x 13.3 cm)
Edition 75 numbered, 25 lettered
Tanglewood Press Inc., New York
Collection Rosa and Aaron H. Esman

89 **Cow Wallpaper Study,** 1966
Screenprint on fluorescent paper collage on Manila paper
40 x 30 1/4 (101.6 x 76.2 cm)
Collection The Andy Warhol Foundation for the
Visual Arts, New York

90 **Cow,** 1966*
Screenprint on wallpaper (one repeat from a 1971
printing shown)
45 1/2 x 29 3/4 (115.57 x 73.66 cm), one repeat
An unknown number of images was manufactured
Printed by Bill Miller's Wallpaper Studio, Inc.
Factory Additions, New York
Collection University Art Museum, CSULB
*Modern replica installation, courtesy The Andy Warhol
Museum, Pittsburgh; not at all venues

91 **Now Aspen in an all New Fab Issue,** 1966
Vol. 1, no. 3, December 1966
A blue cardboard box containing 1 folder, 1 flip book, 1 set of
12 cards, 1 record, 1 calendar, 1 ticket book, 1 pamphlet, 1
flyer, 1 broadside, 1 poster, 1 newspaper, 3 essays, and
1 subscription form
12 1/4 x 9 1/4 x 3/4 (31.1 x 23.4 x 1.9 cm)
Roaring Fork Press Inc., New York
Contributions by L. Reed, J. Smith, A. Warhol, T. Leary, B.
Chamberlain, and others; this issue designed by Warhol and
David Dalton
Collection Steven Leiber

92 **Silver Coke Bottle,** 1967
Silver paint on glass, metal cap
8 x 2 3/8 diameter (20.32 x 6.09 cm)
100 were made to contain perfume "You're In"/"Eau d'Andy"
Museum of Merchandise, Philadelphia
Collection The Andy Warhol Foundation for the
Visual Arts, New York

93 **Andy Warhol's Index (Book),** 1967
Printed book with lithographs, color pop-up illustrations,
and Velvet Underground record, bound and laminated in 3-D
plastic cover
11 1/4 x 8 11/16 (28.6 x 22 cm)
Edition 355 (estimated) signed aside from the trade edition
Random House, New York
Collection University Art Museum, CSULB

94 **Portraits of the Artists,** 1967 (from **Ten from Leo Castelli,** 1968)
100 colored styrene boxes each 2 x 2 x 3/4
(5.1 x 5.1 x 1.9 cm), each silkscreened with a portrait of one
of the ten artists in **Ten from Leo Castelli**
10 portraits of each artist
Edition 200 numbered, 25 lettered
Fabricated by Fine Creations, Inc., New York
Tanglewood Press Inc., New York
Collection Rosa and Aaron H. Esman

ROBERT WATTS (b. 1923, Burlington, Iowa—d.1988, Martin's
Creek, Pennsylvania)

95 **Cabbage,** 1964
Chrome plate on metal, plastic laminate on wood
8 x 8 1/4 x 8 1/4 (20.3 x 20.9 x 20.9 cm) installed on base
Courtesy Larry Miller and Sara Seagull

96 **Cabbage,** 1984
Chrome plate on bronze, plastic laminate on wood
8 1/2 x 7 x 7 (21.5 x 17.7 x 17.7 cm) installed on base
Edition 100
Edition F. Conz, Verona, Italy
Courtesy Larry Miller and Sara Seagull

97 **Schrafft's Chocolate Covered Ice Cream
Drops (4),** c. 1964
Chrome-plated lead
1 x 1 x 1 (2.5 x 2.5 x 2.5 cm) each
Collection University Art Museum, CSULB
Gift of Mr. Ben Birillo

98 **Bacon, Lettuce, and Tomato Sandwich,** 1966
Colored wax and plastic
7 5/8 x 7 1/2 x 2 (19.3 x 19 x 5 cm)
Edition 10
Bianchini Gallery, New York
Private Collection

99 **Egg Box with Eggs,** 1964
Plastic vacuum-formed carton containing
nine white plastic eggs
Carton: 8 1/4 x 6 1/2 x 2 3/4
(20.9 x 16.5 x 6.9) closed
9 white eggs, each 3 1/2 x 5 1/2
(8.8 x 13.9) circumference
Courtesy Larry Miller and Sara Seagull

TOM WESSELMANN (b. 1931, Cincinnati, Ohio)

100 **Untitled (Banner No.1),** c.1963-64
Felt appliqué
72 x 53 (182.9 x 134.6 cm)
Edition 20 projected, number realized unknown
Fabricated by Abacrome, New York
Betsy Ross Flag and Banner Company, New York
Collection of the Artist

101 **Little Nude,** 1966
Original mold
8 x 8 x 1 1/2 (20.3 x 20.3 x 3.8 cm)
Fabricated by Knickerbocker Machine & Foundry, New York
Tanglewood Press Inc., New York
Collection Rosa and Aaron H. Esman

102 **Little Nude,** 1966 (from **7 Objects in a Box**)
Spray-painted vacuum-formed Plexiglas
8 x 8 x 1 1/2 (20.3 x 20.3 x 3.8)
Edition 75 numbered, 25 lettered
Fabricated by Knickerbocker Machine & Foundry, New York
Tanglewood Press Inc., New York
Collection Rosa and Aaron H. Esman

103 **Drawing for Foot Print,** 1966
Pencil on tracing paper
10 5/8 x 9 (26.9 x 22.8 cm)
Collection of the Artist

104 **Seascape (Foot),** 1967
Silkscreened, vacuum-formed Plexiglas (three colors)
14 1/4 x 13 x 11/16 (36.2 x 33 x 1.7 cm)
Edition 101
The Friends of Art, Nelson Gallery-Atkins Museum, Kansas City
Collection of the Artist

105 **Nude,** 1969
Vinyl (or felt) banner with fourteen colors
60 x 72 (152.4 x 182.9 cm)
Edition 20 each projected, number realized unknown
Fabricated by Abacrome, New York
Betsy Ross Flag and Banner Company/Multiples Inc., New York
Courtesy Multiples Inc., New York (Collection of the Artist)

MISCELLANEOUS

106 **Ray Gun Spex Books** (9), 1961
Claes Oldenburg (2), Jim Dine (3), Robert Whitman (2),
Richard O. Tyler (1), Red Grooms (1)
8 1/2 x 5 1/2 (21.6 x 14 cm) each
Mimeograph on paper
Collection Claes Oldenburg and Coosje van Bruggen

107 **American Supermarket** (announcement), 1964
Silkscreen on paper
17 x 22 (43.1 x 55.8 cm)
Collection University Art Museum, CSULB
Gift of Mr. Ben Birillo

108 **1¢ Life,** 1964
Written by Walasse Ting
Edited by Sam Francis
16 3/4 x 12 1/4 x 1 1/2 (42.5 x 31.1 x 3.8 cm)
Edition 2000 numbered (regular), 100 signed (special)
Lithography by Maurice Beaudet, Paris
Typography by Georges Girard Press, Paris
Published by E.W. Kornfeld, Bern
Collection University Art Museum, CSULB

109 Original handboxed announcement for
7 Objects in a Box, 1966
Balsa wood box containing photographs of each work
2 5/16 x 3 5/8 x 7/8 (5.9 x 9.2 x 2.2 cm)
Collection Rosa and Aaron H. Esman

110 Original container for **7 Objects in a Box,** 1966
Custom, handmade crate with die-cut stencil
21 1/4 x 16 5/8 x 13 1/2, (53.3 x 40 x 33 cm)
Designed by Rosa Esman with Alan Hackett
Collection Rosa and Aaron H. Esman

111 **S.M.S.,** 1968
A collection of 73 original multiples presented in six portfolios
13 1/2 x 7 1/2 (34.3 x 19 cm) each
Edition 2000
William Copley workshop and various fabricators
The Letter Edged in Black Press Inc., New York
Collection University Art Museum, CSULB

112 **The Moon Museum,** 1968
Lithograph with Tantalum as color on Tantalum nitride surface,
fused to a base of Alumina (A1 0) ceramic wafer
9/16 x 3/4 x 1/32 (22 x 2 x .3 cm)
Project initiated by Forrest Myers in collaboration with Fred D.
Waldhauer; artists John Chamberlain, Forrest Myers, David
Novros, Claes Oldenburg, Robert Rauschenberg,
and Andy Warhol
Collection Billy Klüver

LENDERS TO THE EXHIBITION

Benjamin Birillo II, New York
Campbell-Thiebaud Gallery, San Francisco
Jim Dine, New York
Rosa and Aaron H. Esman, New York
Gemini G.E.L., Los Angeles
Multiples Inc., New York
The Grinstein Family, Los Angeles
Jon and Joanne Hendricks, New York
O.K. Harris, New York
Billy Klüver, Berkeley Heights, New Jersey
Joan Kron, New York
David and Mitchell Lichtenstein, New York
Roy Lichtenstein, New York
Steven Leiber, San Francisco
Brad and Karen Lowe, San Diego
Norton Simon Museum, Pasadena, California
Claes Oldenburg and Coosje van Bruggen,
 New York
Kimiko and John Powers, Carbondale, Colorado
James Rosenquist, New York and Aripeka, Florida
Edward Ruscha, Venice, California
Pace Editions, New York
Betty Jean Thiebaud, Sacramento
Wayne Thiebaud, Sacramento
University Art Museum, CSULB, Long Beach,
 California
The Andy Warhol Foundation for the Visual
 Arts, New York
The Andy Warhol Museum, Pittsburgh
Larry Miller and Sara Seagull, New York
Tom Wesselmann, New York

PHOTOGRAPHY CREDITS

Cover, Ken Heyman, courtesy Woodfin Camp and Associates, Inc.; 6, Stephen Shore; 7, courtesy Norton Simon Museum, Pasadena, CA; 9, courtesy Marlborough, NY; 10, Rider and Mott; 11, courtesy Marlborough, NY; 12, John Bryson; 14-15, 23, Henri Dauman/Dauman Pictures, NYC; 16, Larry Lemay, courtesy The Andy Warhol Foundation for Visual Arts, Inc.; 17, Ken Heyman, courtesy Woodfin Camp and Associates, Inc. (top image), Mark Chamberlain (bottom image); 20, Robert McElroy; 21, Joel Conison (6 images); 22, Ellen Johnson, courtesy The Archives of The Andy Warhol Museum, Pittsburgh, Founding Collection, Contribution The Andy Warhol Foundation for Visual Arts, Inc.; 24, courtesy The Archives of The Andy Warhol Museum, Pittsburgh, Founding Collection, Contribution The Andy Warhol Foundation for Visual Arts, Inc. (top image), Mark Chamberlain (inset); 25, Mark Chamberlain; 26, Jerry McMillan; 27, Paul Ruscha (top image), courtesy Multiples Inc., NY (center image), courtesy Tom Wesselmann (bottom image); 28, courtesy Roy Lichtenstein; 29, Peter Foe; 30, Ken Heyman, courtesy Woodfin Camp and Associates, Inc.; 31, Mark Chamberlain; 33, Mark Chamberlain; 34-35, Ken Heyman, courtesy Woodfin Camp and Associates, Inc.; 36, Jerry Sachs, courtesy Ben Birillo (top image), Henri Dauman/Dauman Pictures, NYC (bottom image); 37, Sara Seagull, courtesy Robert Watts Studio Archive, NY (top image), Robert Watts, courtesy Robert Watts Studio Archive, NY (bottom image); 38, Ken Heyman, courtesy Woodfin Camp and Associates, Inc.; (2 images); 39, Peter Moore, courtesy the Estate of Peter Moore; 41, courtesy Marlborough, NY; 42, Joel Conison; 43, courtesy Marlborough, NY; 44, courtesy Multiples Inc.; 45, courtesy Roy Lichtenstein; 47, Robert McKleever, 48, Ferrari Color, Sacramento, CA; 49, Joel Conison; 50, courtesy Roy Lichtenstein (2 images); 51, courtesy Marlborough, NY; 54, courtesy Marlborough, NY; 55, Russ Blaise; 56, Joel Conison; 57, courtesy Marlborough, NY; 58, courtesy Tom Wesselmann; 59, courtesy The Archives of The Andy Warhol Museum, Pittsburgh, Founding Collection, Contribution The Andy Warhol Foundation for Visual Arts; 60, The New York Times Photo Studio (Gene Maggio)/NYT Permissions, courtesy Joan Kron; 61, courtesy Gemini G.E.L.; 62, Larry Lemay, courtesy The Andy Warhol Foundation for the Visual Arts; 63, Seymour Mednick, courtesy Judith and Joel Golden; 64, courtesy The Archives of the Andy Warhol Museum, Pittsburgh, Founding Collection, Contribution The Andy Warhol Foundation for the Visual Arts, Inc.; 65, Ken Heyman; 66-67, Joel Conison; 68, courtesy Jim Dine (top image), courtesy Petersburg Press (bottom image); 69, courtesy PaceWildenstein; 70, courtesy Sotheby's, NY; 71, Joel Conison (top image), Malcolm Lubliner, courtesy Gemini G.E.L. (center and bottom images); 72-73, Joel Conison; 74, Rueben Beckett; 75, courtesy Marlborough, NY; 76, courtesy Pace Editions (top image), courtesy James Rosenquist (bottom image); 77, Mark Chamberlain; 78-79, Eric Pollitzer; 80, Robert Watts, courtesy Roberts Watts Studio Archive; 81, Bert Stern/NYT Permissions; 82, courtesy University Art Museum; 83, courtesy Roy Lichtenstein; 84, Bert Stern/NYT Permissions; 85, courtesy Roy Lichtenstein; 86, Frank J. Thomas; 87, courtesy Multiples, Inc., NY (top image), courtesy Petersburg Press (bottom image); 89-93, courtesy Gemini G.E.L.; 106-107 courtesy Marlborough, NY

SMART ART PRESS

POW! ZAP! This smashing book (thanks Connie, Susan and Marika) is at once a 60s reminiscence, a reference book and a Pop multiple in its own right. Like the works it unearths and documents, the 3000 copies of this first edition are likely to be coveted by art-loving folks wherever the exhibition travels – and indeed, where the four winds blow.

Our list of current and future titles. Groove!

–TOM PATCHETT, Publisher